Quilts from
Larkspur Farm

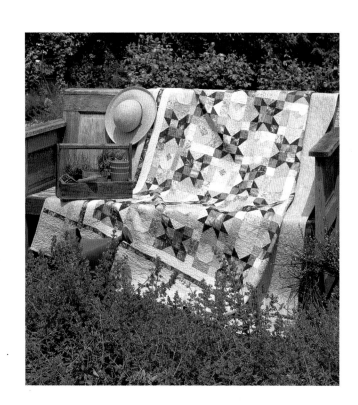

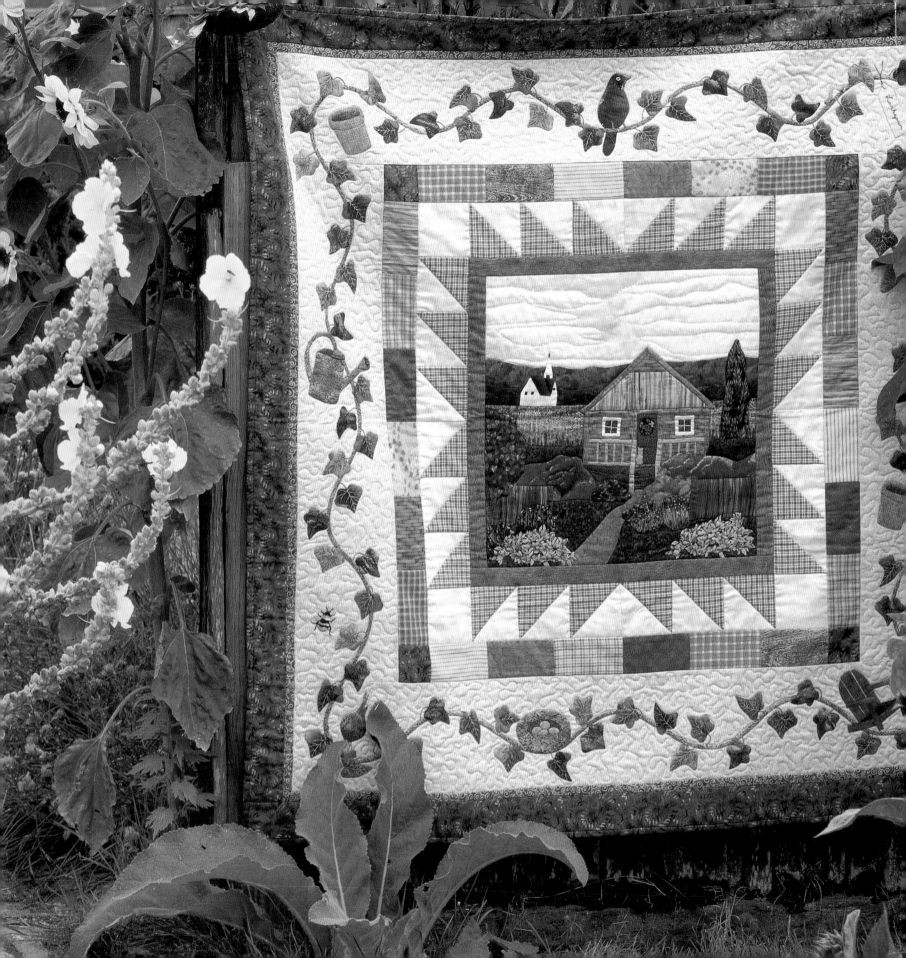

Quilts from
Larkspur Farm

Pamela Mostek and
Jean Van Bockel

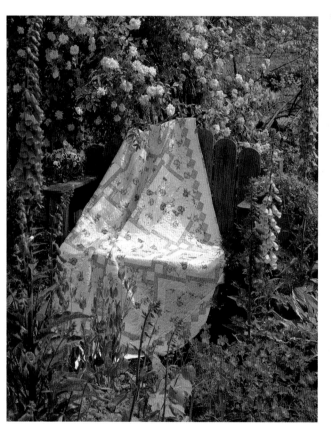

Martingale™
& COMPANY

Quilts from Larkspur Farm

© 2002 by Pamela Mostek and Jean Van Bockel

That Patchwork Place® is an imprint of Martingale & Company™.

Martingale & Company
20205 144th Ave. NE
Woodinville, WA 98072-8478
www.martingale-pub.com

CREDITS

President: Nancy J. Martin
CEO: Daniel J. Martin
Publisher: Jane Hamada
Editorial Director: Mary V. Green
Managing Editor: Tina Cook
Technical Editor: Barbara Weiland
Copy Editor: Liz McGehee
Design Director: Stan Green
Illustrator: Laurel Strand
Cover and Text Designer: Stan Green
Photographer: Brent Kane

Printed in Singapore
07 06 05 04 03 8 7 6 5 4 3 2

Library of Congress Cataloging-in-Publication Data

Mostek, Pamela.
 Quilts from Larkspur Farm / Pamela Mostek
 and Jean Van Bockel.
 p. cm.
 Includes bibliographical references.
 ISBN 1-56477-384-1
 1. Patchwork—Patterns. 2. Quilting—Patterns.
 3. Gardens in art. 4. Larkspur Farm.
 I. Van Bockel, Jean. II. Title.

Mission Statement

We are dedicated to providing quality products and service by working together to inspire creativity and to enrich the lives we touch.

Acknowledgments

While working on this book, we were fortunate to receive encouragement and enthusiasm from so many people. Our most sincere thanks to all of you who were there to answer our questions and give your advice and support. A special thank-you from both of us to:

The Soup Kitchen Quilters, who enthusiastically cheered us on through the development of our book;

The Mumm's The Word team, for the invaluable and enjoyable experience of working with all of them;

Everyone at Martingale & Company who had faith in our great book idea and helped make our vision a reality;

The staff of Alto's EZ Mat for their Quilt Cut. It made cutting fabrics so much easier.

And Jan Johnson, who cheerfully and artfully provided treasures and assistance for the photo shoots.

Pam would also like to thank:
My friend Carol MacQuarrie, for the lovely job she did on the machine quilting—and for always making time to squeeze us in when we needed her;

My friend Edi Dobbins, for all her help with piecing and cutting—and for all her helpful suggestions;

My daughters, Stacey and Rachel, who are always my best critics and greatest supporters; thanks for thinking your mom can do anything!

My longtime friend, Patti Eaton, who was always just a phone call away when I needed her creative ideas and her wise shopowner advice;

And my husband, Bob, who has patiently helped and supported me in all my creative efforts over the years. I couldn't have done it without you!

Jean would also like to thank:
My husband, Mark, who started creating great meals just to survive—and enthusiastically read to me while I appliquéd;

And my daughters, Wren and Kitty, for their great critiques and undying support of good old Mom.

Dedication

To Jan Johnson, owner of Larkspur Farm. With her lovely garden spot for inspiration, creating the quilts for this book was a joy.

Contents

Welcome to Larkspur Farm!

ARDEN ELEGANCE and cottage-style beauty—that's Larkspur Farm. Nestled in the luscious greenery of western Washington State in the Pacific Northwest, this garden spot is a true delight.

From our very first visit, we knew Larkspur Farm was a place of endless inspiration for beautiful quilts. Lush beds of flowers in bloom, abundant trailing vines, and unpredictable pieces of garden art abound there. All it needed, in our eyes, was an array of colorful quilts to become a perfect haven! And so we began.

Our quilts tell the story of this magical spot. Some are bold and dramatic, inspired by the intense color in every corner. Others are soft, reflecting the delicate beauty of the farm's rose-covered arbors and whitewashed garden house. Fun and nostalgia are tucked among the blooms too. Where else would you find a flower stand where passersby are on the honor system to put money in the box for a fresh bouquet that strikes their fancy?

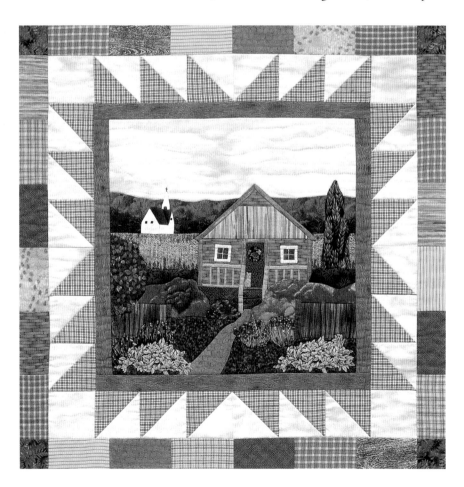

 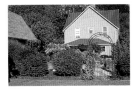 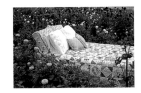 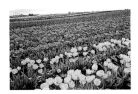

As we became better acquainted with Larkspur Farm, we were reminded of a time-honored truth: quilts and gardens are wonderful companions. Both add an irreplaceable aura of beauty to each day. No wonder they are both on our lists of favorite things.

We hope seeing our quilts in this wonderful garden spot will inspire you to add them to your own outdoor surroundings for an unexpected touch of color and beauty. Who said that all quilts must be protected and stored away for the next generation? Use them!

Throw one over the fence when you have a backyard gathering. Spread a favorite family quilt on the grass and enjoy a picnic lunch. Or drape one over your favorite chair on the back porch. Cherished quilts and lovingly tended gardens can be perfect companions, as you will see throughout this book.

Enjoy your visit to Larkspur Farm by browsing through the photographs of this exquisite setting. We know you'll love creating the wonderful quilts that it inspired too.

Pam and Jean

More About Larkspur Farm

Larkspur Farm is located near Mount Vernon, Washington, in the heart of Skagit County's tulip country and on the road to the popular destination of La Conner. It is the site of many lovely garden weddings and festivities, and guests come from throughout the area to enjoy its country-garden beauty. Owner Jan Johnson hosts and coordinates the events at Larkspur Farm.

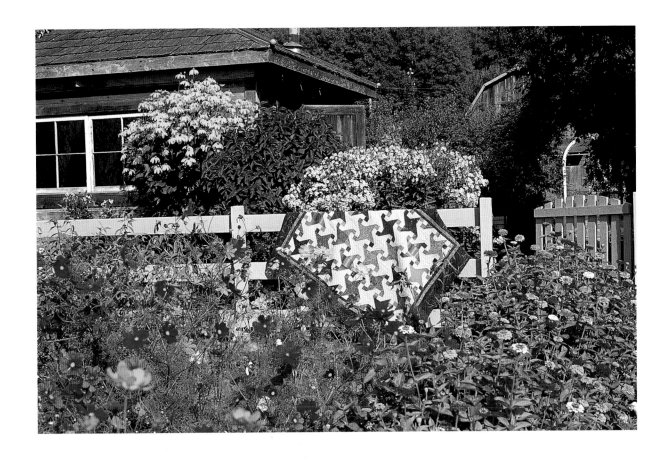

Jan Johnson

A Quick Tour

WE'RE SO PLEASED to share Larkspur Farm with you through the beautiful photographs in this book and the array of quilts it inspired us to create. With each project, you'll find glimpses in words or pictures of just what makes this very favorite spot such a visitor's delight. From the vintage garden house that welcomes guests, to the formal herb garden where you'll find an elegant tea being served, we hope you enjoy the tour!

Each stop along the way includes a lovely quilt—a perfect accent to the garden spot that inspired it. We've included a variety of projects and techniques, so there's something for everyone. Whether you're a beginning quilter or one with years of experience, we're sure you'll find a quilt that's perfect for you.

Gardens are certainly all about color and so is our book. We've used dozens and dozens of irresistible shades and prints in many of the quilts, such as "Pressed Flowers" and "Tulip Festival." Others, such as "Poppy Fields" and "Zinnia Patch," were created in the vivid colors of the flowers that inspired them.

Along with color, we love appliqué! Trailing appliquéd vines and leaves highlight the "Garden House Dresser Scarf" and the "Hollyhocks" quilt. And, as a fitting tribute to this charming place, we created the "Larkspur Farm Quilt"—an appliquéd collection of the favorite treasures we found in the gardens.

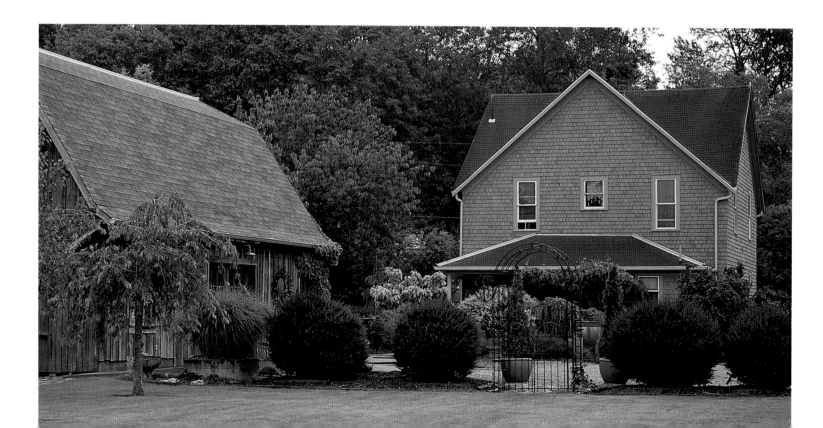

We've also included tips on drying flowers, garden collecting, hosting a garden tea, and making a rose ice bucket—a festive tradition created for weddings and other very special events in Pam's family.

To assist you in constructing your quilt or answering your questions, you'll find general instructions and sewing methods in the back of the book, along with a list of helpful references if you want to find out more about a particular technique.

Now that you know what's in store, let's really begin the tour! The delights of *Quilts from Larkspur Farm* await. Enjoy the journey!

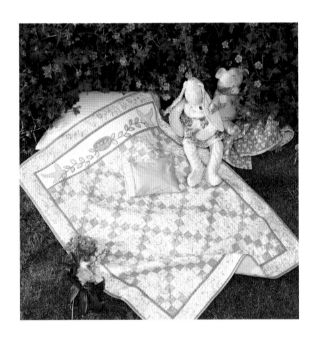

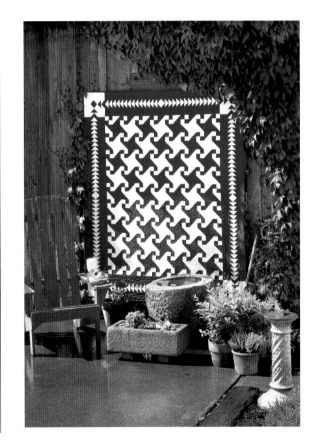

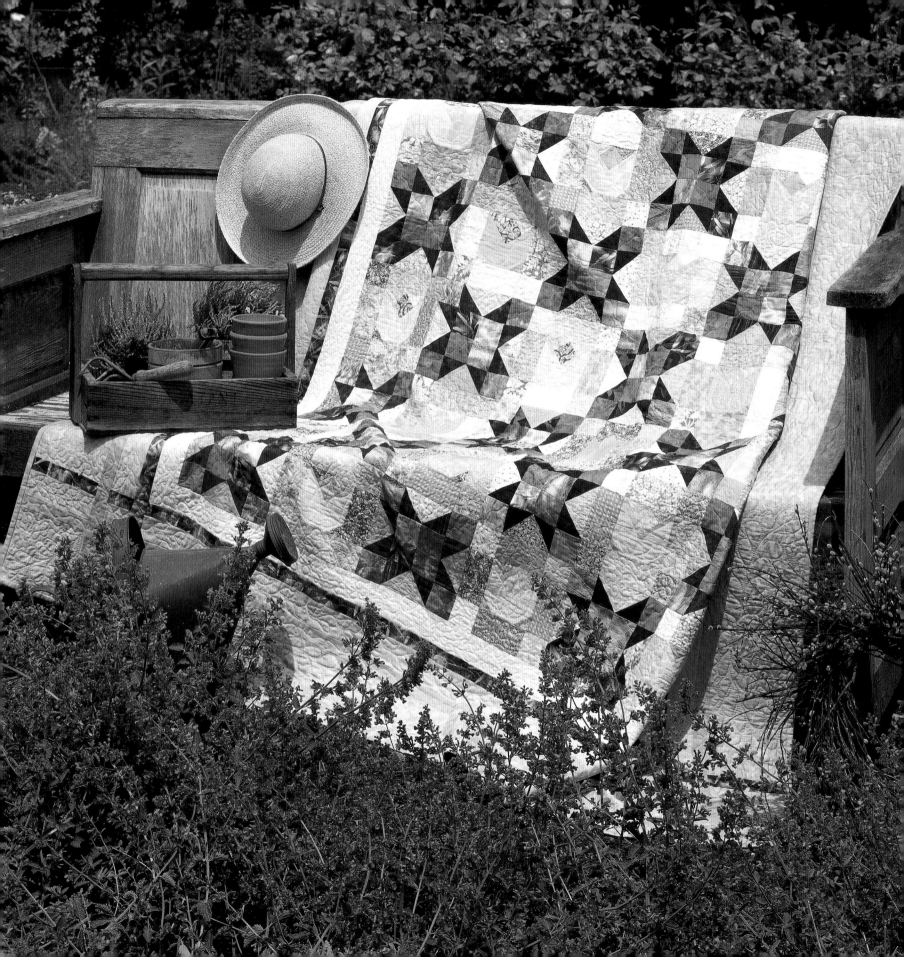

Tulip Festival

It's a celebration of spring! Field after field of brightly blooming tulips dot the landscape this time of year

in the area surrounding Larkspur Farm. Thousands of visitors enjoy the colorful scenes of the

countryside awash in color during the Skagit County Tulip Festival, the inspiration

for this quilt in tulip shades of yellow and purple.

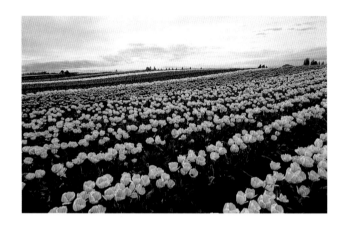 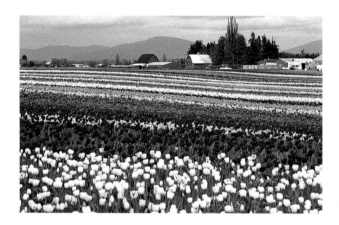

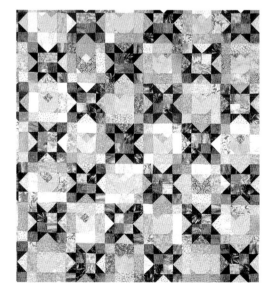

Materials

All yardage is based on 42"-wide fabric unless otherwise stated.

- 1 yd. assorted yellow prints for Tulip blocks
- 3 yds. assorted light and medium green prints for background
- 1¼ yds. assorted dark purple prints for Star blocks
- 1¼ yds. assorted rose and light purples for Star blocks

- ⅝ yd. green print for inner border #1
- ½ yd. dark purple print for inner border #2
- ⅔ yd. green print for middle border
- ½ yd. light purple print for outer border #1
- 1⅝ yds. green for outer border #2
- 7½ yds. for backing
- ¾ yd. for binding
- 88" x 104" piece of batting

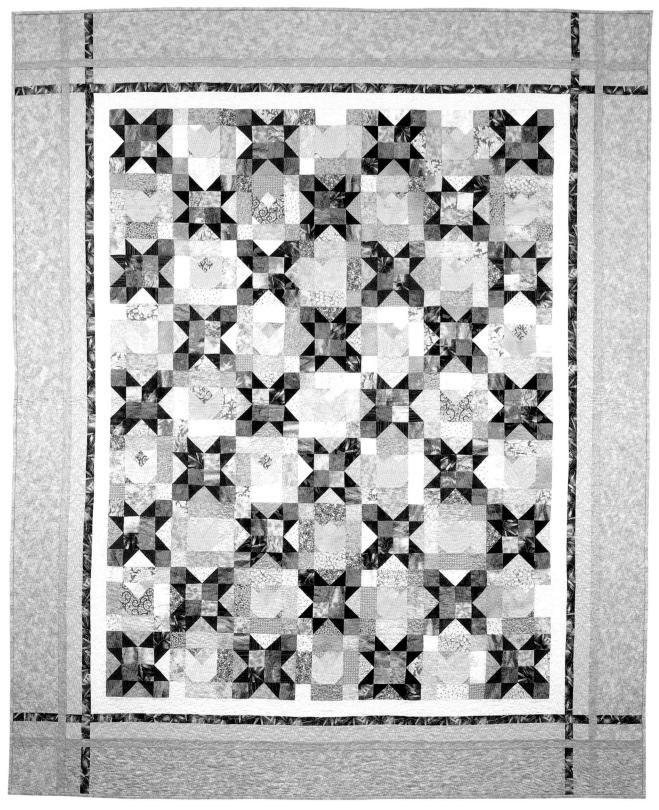

TULIP FESTIVAL
By Pamela Mostek, 2000, Cheney, Washington, 80" x 96".

Cutting

Cut all strips across the fabric width. All measurements include ¼"-wide seam allowances.

From the assorted yellow prints, cut:
- 31 rectangles, each 2½" x 4½"
- 122 squares, each 2½" x 2½"

From the assorted green prints, cut:
- 60 squares, each 1½" x 1½"
- 186 squares, each 2½" x 2½"
- 252 rectangles, each 2½" x 4½"

From the assorted dark purple prints, cut:
- 256 squares, each 2½" x 2½"

From the assorted rose and light purple prints, cut:
- 256 squares, each 2½" x 2½"

From the green print for inner border #1, cut:
- 7 strips, each 2½" wide

From the dark purple print for inner border #2, cut:
- 9 strips, each 1½" wide; set 7 strips aside and crosscut 2 strips into:
 - 4 rectangles, each 1½" x 2½"
 - 4 rectangles, each 1½" x 3½"
 - 8 rectangles, each 1½" x 6½"

From the green print for middle border, cut:
- 8 strips, each 2½" wide; set 7 strips aside and cut 1 strip into 4 squares, each 2½" x 2½"

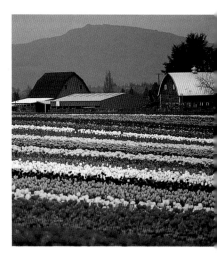

From the light purple for outer border #1, cut:
- 10 strips, each 1½" wide; set 7 strips aside and crosscut 3 strips into:
 - 4 squares, each 1½" x 1½"
 - 4 rectangles, each 1½" x 2½"
 - 4 rectangles, each 1½" x 6½"
 - 4 rectangles, each 1½" x 10½"

From the green for outer border #2, cut:
- 9 strips, each 6½" wide; set 6 strips aside and crosscut 2 strips into:
 - 8 rectangles, each 2½" x 6½"
 - 4 squares, each 6½" x 6½"

From the binding fabric, cut:
- 9 strips, each 2¾" wide

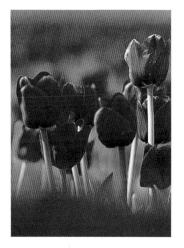

Making the Tulip Blocks

Have fun mixing your fabric combinations to make each Tulip and Star block unique.

1. With right sides together, place a 2½" yellow square on a 2½" green square. On one of the squares, draw a light pencil line diagonally from corner to corner. Stitch on the line and cut ¼" from the stitching. Make 2. Discard the cutaway corners and press the seam toward the green triangle in each unit.

Make 2.

2. With right sides together, position 1 yellow 2½" square on top of each triangle unit from step 1. Referring to the illustration,

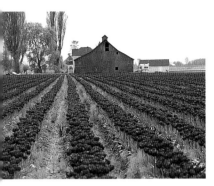

stitch diagonally from corner to corner, crossing the previous seam line in each one. Cut ¼" from the stitching and press the seam toward the larger triangle in each unit.

Make 1. Make 1.

3. Sew the units from step 2 together to complete the top section of the tulip. Press the seam in one direction. Add a 2½" x 4½" yellow rectangle to the bottom edge. Press the seam toward the rectangle.

4. At each lower corner, position a 1½" green square and stitch diagonally from corner to corner. Cut ¼" from the stitching and press the seams toward the lower corners.

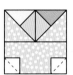 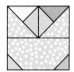

5. Arrange the completed tulip with 2½" x 4½" green rectangles and 2½" green squares as shown and sew together to complete the Tulip block. Press in the direction of the arrows.

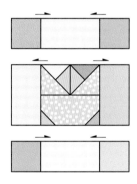 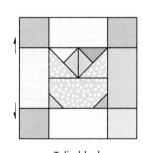

Tulip block
Make 31.

6. Repeat steps 1–5 to make 31 Tulip blocks.

Making the Star Blocks

1. Sew 4 rose or light purple 2½" squares together in pairs; press. Sew the pairs together to make a four-patch star center.

Make 1
for each block.

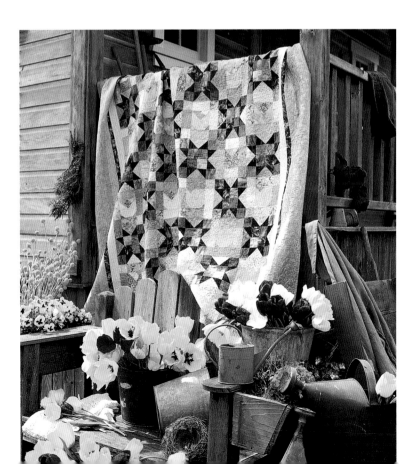

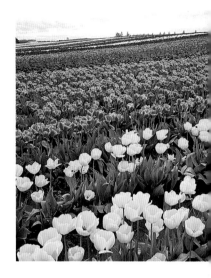

2. With right sides together, position and stitch a dark purple 2½" square to one end of each of 4 green 2½" x 4½" rectangles. Stitch diagonally from corner to corner, cut ¼" from the stitching, and press toward the triangle. Repeat at the opposite end of each rectangle to make 4 units.

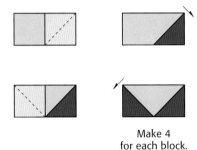

Make 4
for each block.

3. Arrange the triangle units with the four-patch center and 2½" rose or light purple squares to make the block. Sew the pieces together in rows and join the rows. Press in the direction of the arrows.

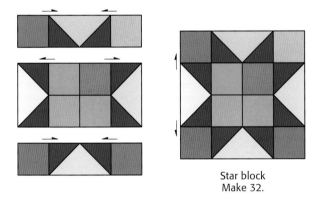

Star block
Make 32.

4. Repeat steps 1–3 to make 32 Star blocks.

Assembling the Quilt Top

1. Referring to the quilt photo on page 12, arrange the Star and Tulip blocks in alternating fashion to make 9 rows of 7 blocks each. Sew the blocks together in rows and press the seams toward the Tulip blocks.

2. Sew the rows together to create the quilt-top center. Press.

3. Cut a 2½"-wide green inner border #1 strip in half and sew a half strip to the end of 2 green inner border #1 strips.

4. Measure the quilt top through the center and trim the strips to match this measurement (approx. 56½"). Stitch to the top and bottom edges of the quilt top. Press the seams toward the border.

5. Sew the remaining 4 green inner border #1 strips together in pairs. Measure the quilt length through the center and trim the strips to match (approx. 76½"). Sew to the remaining quilt-top edges.

6. To assemble top and bottom border units, cut 2 dark purple 1½"-wide inner border #2 strips in half. Repeat with 2 green 2½"-wide middle border strips, 2 light purple 1½"-wide outer border #1 strips, and 2 green 6½"-wide outer border #2 strips. Stitch each half strip to one of the remaining matching-color border strips. Measure the quilt top through the center and trim each of the border strips to match (approx. 60½").

7. Arrange the pieced border strips in 4 sets in the order shown and sew together to make 2 multiborder strips. Press the seams in the direction of the arrow. Sew to the top and bottom edges of the quilt top.

8. To assemble the side multiborder strips, sew the remaining dark purple, green, light purple, and green outer border strips together in pairs. Trim each strip to match the quilt-top measurement through the center (approx. 76½"). Arrange in the order shown for the top and bottom borders; press and set aside.

9. For the border corner squares, arrange and sew the dark and light purple and green rectangles and squares into the rows shown. Press seams in the direction of the arrows. Sew the units together to make 4 corner squares.

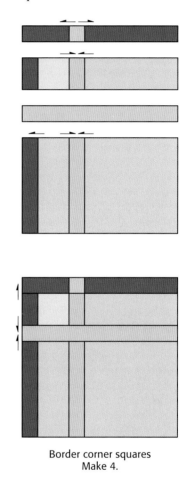

Border corner squares
Make 4.

10. Sew a corner square to each end of the remaining 2 multiborder strips. Press the seams toward the border strips. Sew the resulting borders to the sides of the quilt top. Press.

Finishing Your Quilt

Refer to the "General Directions," beginning on page 117, for specific directions in each of the following finishing steps.

1. Layer the quilt top with batting and backing; baste.

2. Machine or hand quilt as desired.

3. Trim the quilt batting and backing even with the quilt-top edges.

4. Sew the 2¾"-wide binding strips together into one long strip and bind the quilt.

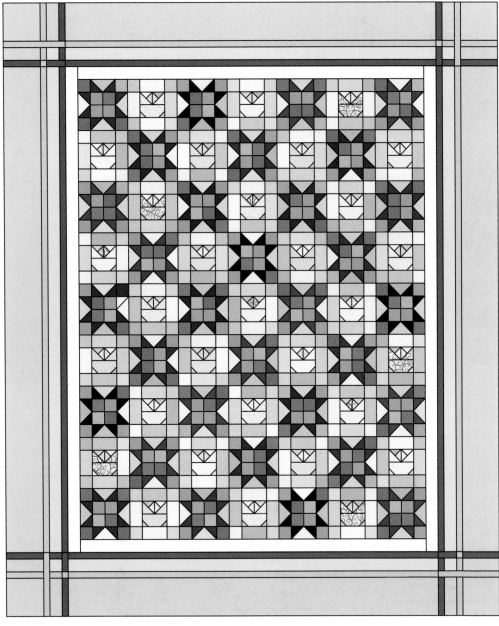

Quilt Plan

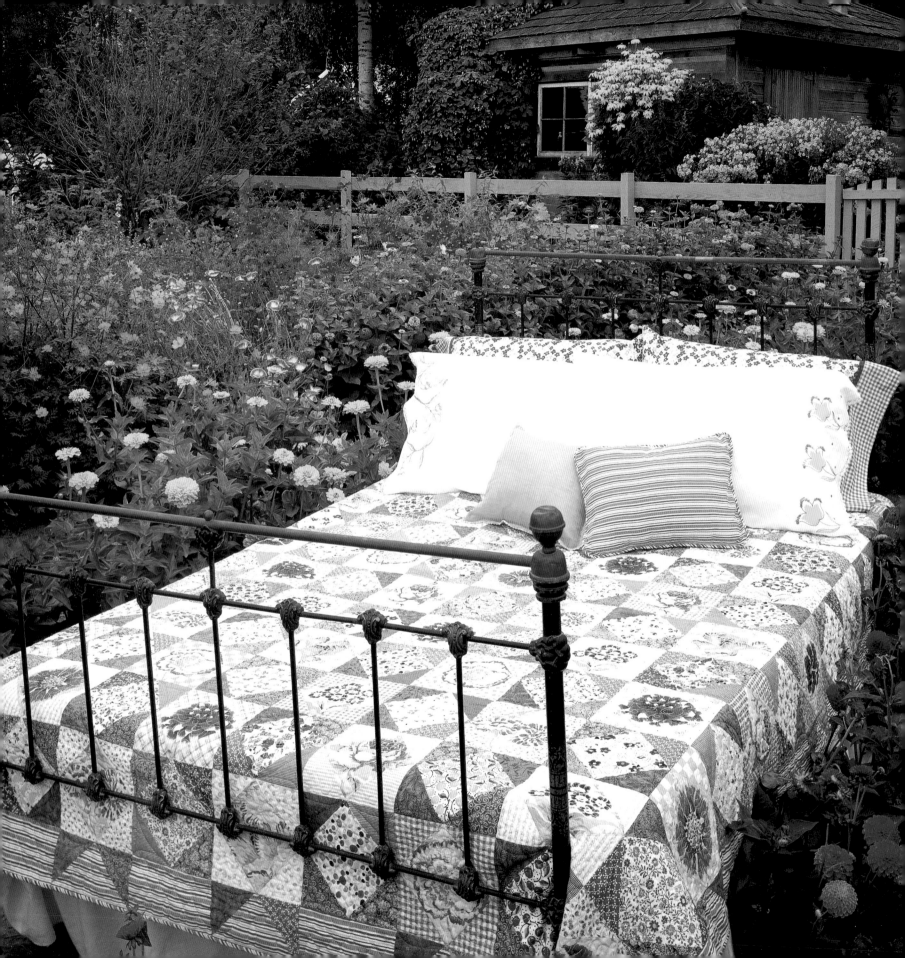

Flower Bed

What a delightful fantasy—sleeping in a bed of fragrant flowers and beautiful foliage

at Larkspur Farm! To make the fantasy complete, imagine wrapping yourself in the luxury

of this beautiful quilt, awash in bright garden colors.

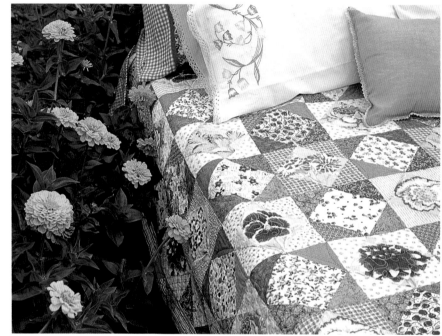

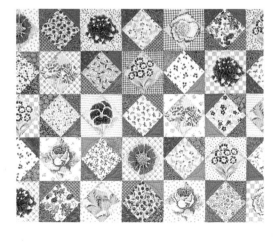

Materials

All yardage is based on 42"-wide fabric unless otherwise stated.

- 1⅞ yds. to 2¾ yds. large-scale floral print for block centers*
- 1¾ yds. assorted medium-scale prints for alternate centers
- 2¼ yds. assorted geometric prints
- 2¾ yds. assorted green prints
- 1¾ yds. striped fabric for border and binding
- 8¼ yds. for backing
- 92" x 106" piece of batting

** Purchase the larger amount if you wish to "fussy cut" each square with a flower centered in each one (see "Cutting" on page 21).*

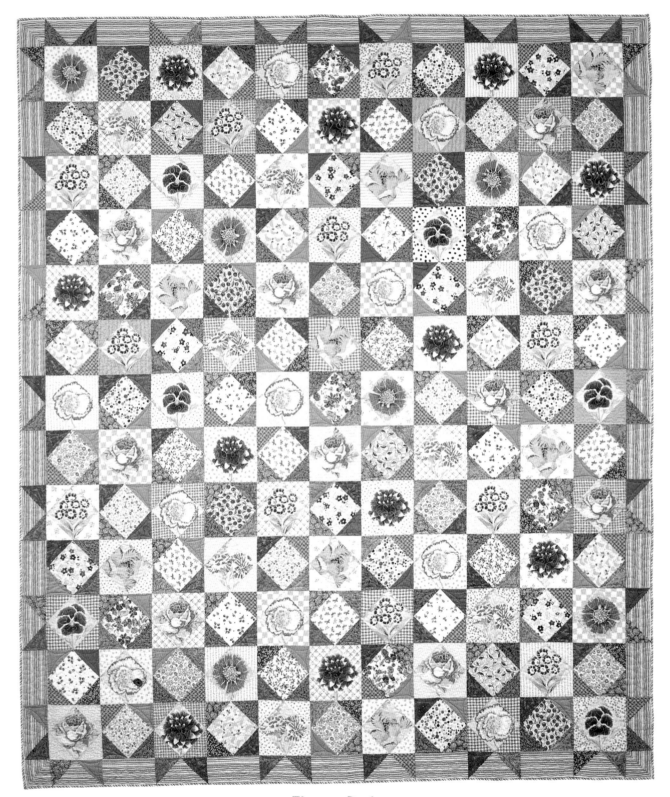

Flower Bed
By Jean Van Bockel, 2001, Coeur d'Alene, Idaho, 84" x 98".

Cutting

Cut all strips across the fabric width. All measurements include ¼"-wide seam allowances.

From the large-scale floral print, cut:
- 11 strips, each 5½" wide; crosscut into 72 squares, each 5½" x 5½", OR "fussy cut" 72 squares, centering a motif in each one. Use a 6"-square ruler to make the first cuts, then trim each to 5½" square to fine-tune the flower centering.

From the assorted medium-scale prints, cut:
- 11 strips, each 5½" wide; crosscut into 71 squares, each 5½" x 5½"

From the assorted geometric prints, cut:
- 16 strips, each 4½" wide; crosscut into 144 squares, each 4½" x 4½"; cut squares once diagonally for a total of 288 triangles

From the assorted green prints, cut:
- 16 strips, each 4½" wide; crosscut into 142 squares, each 4½" x 4½"; cut once diagonally for a total of 284 triangles
- 6 strips, each 4" wide; crosscut into 52 squares, each 4" x 4"

From the striped fabric, cut:
- 5 strips, each 7½" wide; crosscut into 48 rectangles*, each 4" x 7½"
- 4 squares, each 4⅜" x 4⅜"*
- Enough 2"-wide bias strips to make a 374"-long strip for binding.

Cut identical pieces, centering the same color stripe in each one.

Making the Flower Blocks

Sew 2 matching geometric print triangles to opposite sides of each 5½" floral square. Press the seams toward the triangles. Add matching triangles to the remaining edges in the same manner and press. Check the block measurements and trim to 7½" square if necessary. Make 72.

Make 72.

Make the Alternate Blocks

Repeat the steps in "Making the Flower Blocks" above, sewing 2 different green print triangles to opposite sides of each 5½" medium-scale print square. After pressing, sew 2 different green print triangles to the remaining sides. Press. Make 71. Measure blocks and trim if necessary. Note that all 4 triangles in the unit are different green prints.

Make 71.

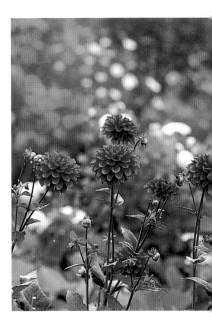

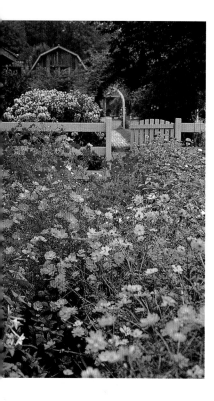

Making the Border and Border Corner Units

1. On the wrong side of each of the 4" green squares, draw a diagonal line with a sharp pencil. Place a marked square at the left end of a 4" x 7½" striped rectangle with the diagonal line positioned as shown. Stitch on the line, cut away the corner ¼" from the stitching, and press the seam toward the triangle. Repeat, adding a different 4" green square to the other end of the rectangle. Make 26.

Stitch and trim. Press.

Make 26.

2. On the cutting mat, position 2 striped 4⅜" squares with the stripes running up and down and 2 with the stripes running side to side. Cut each stack of squares once diagonally, for a total of 8 triangles.

Cut 2 squares with stripes oriented vertically. Cut 2 squares with stripes oriented horizontally.

3. Sew the vertical striped triangles to the horizontal striped triangles in pairs, taking care to match the stripes along the diagonal seam in each one. Press the seam open. Make 4.

Make 4.

4. Assemble top and bottom border strips, using the pieced squares, pieced rectangles, and striped rectangles in the order shown below. Press seam allowances to the left in each border strip.

Assembling the Quilt Top

1. Referring to the illustration below, arrange the floral and alternate blocks in rows.

Press.

Make 2 border strips.

Press.

Make 7 rows.

Press.

Make 6 rows.

Make 7 rows that begin and end with a large floral block and add a pieced striped rectangle to each end. Sew the blocks together in each row and press the seams to the right in each row.

2. Make 6 rows that begin and end with the alternate block, adding a plain striped rectangle to each end. Press the seams to the left in each row, as shown above.

3. Sew the rows together and press the seams in one direction.

Finishing Your Quilt

Refer to the "General Directions," beginning on page 117, for specific directions in each of the following finishing steps.

1. Divide the backing into 3 pieces, each $2\frac{5}{8}$ yards long. Join the long edges to make a backing composed of 3 strips that will run horizontally across the width of the quilt. Press the seams open.

2. Layer the quilt top with the backing and batting; baste.

3. Machine or hand quilt as desired.

4. Trim the batting and backing even with the quilt-top edges.

5. Sew the 2"-wide, bias-cut, striped binding strips together into one long strip and bind the quilt.

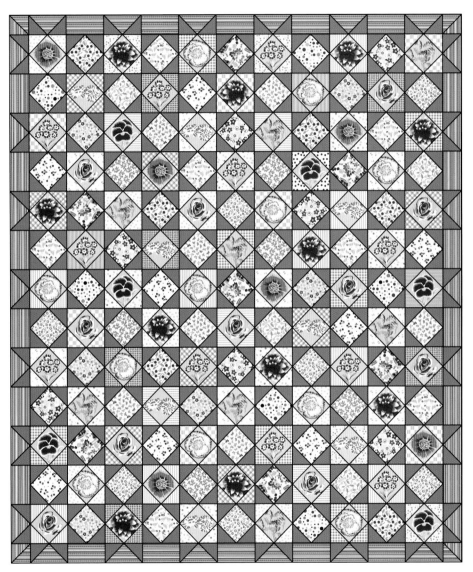

Quilt Plan

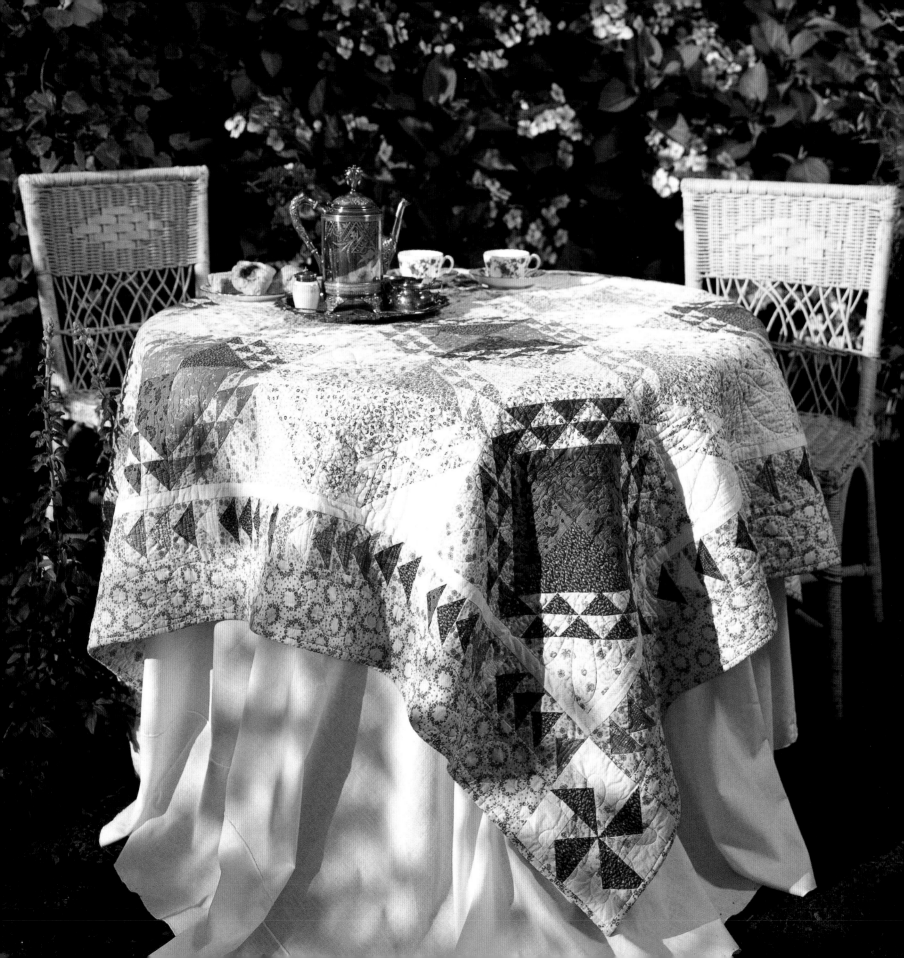

A Little Blue Sky

Contrary to popular belief, the sun does shine through, and you can see the sky even in the far northwestern corner of the rainy Pacific Northwest. And when the sun does shine, the sky is a celebration of gorgeous shades of summertime blues, just like those in this dramatic quilt—
a tribute to the blue skies of Larkspur Farm.

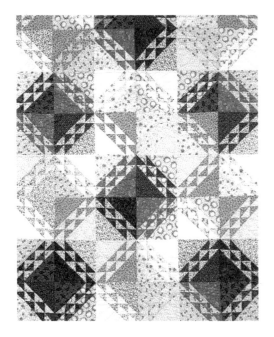

Materials

All yardage is based on 42"-wide fabric unless otherwise stated.

- 3½ yds. assorted light solids and light blue prints for blocks and flying-geese border
- 3½ yds. assorted medium and dark blue prints for blocks and flying-geese border
- ⅜ yd. light solid for inner border
- 1⅝ yds. light print for outer border and binding
- 5 yds. for backing
- 72" x 88" piece of batting

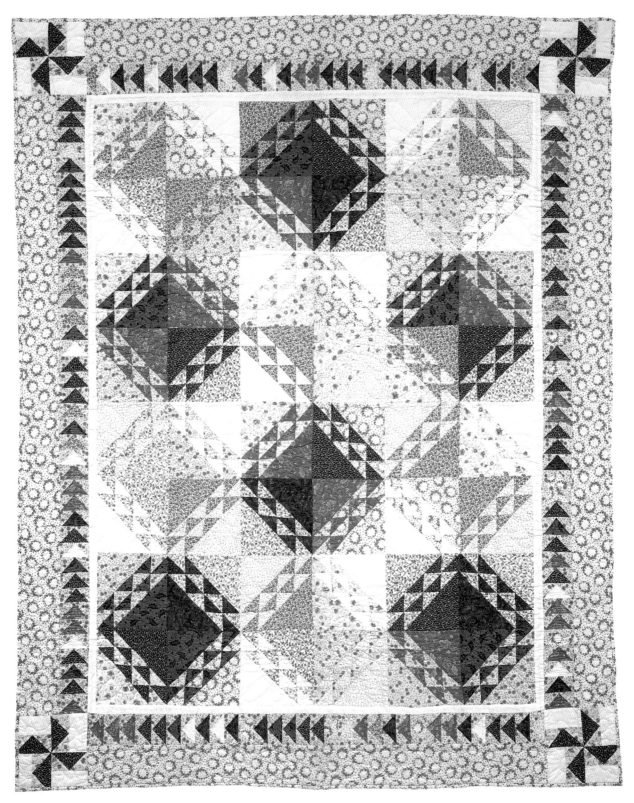

A Little Blue Sky
By Pamela Mostek, 1999, Cheney, Washington, 63½" x 80".

Cutting

Cut all strips across the fabric width. All measurements include ¼"-wide seam allowances.

From the light solids and light blue prints, cut:
- 5 strips, each 6⅞" wide; crosscut into 24 squares, each 6⅞" x 6⅞"; cut once diagonally to make a total of 48 triangles
- 13 strips, each 2⅞" wide; crosscut into 168 squares, each 2⅞" x 2⅞"; cut once diagonally for a total of 336 triangles
- 4 strips, each 2¼" wide; crosscut into:
 16 rectangles, each 2¼" x 4"
 32 squares, each 2¼" x 2¼"
- 16 strips, each 2" wide; crosscut 16 strips into 304 squares, each 2" x 2"; crosscut the remaining 2 strips into 30 rectangles, each 2" x 3½"

From the assorted medium and dark blue prints, cut:
- 5 strips, each 6⅞" wide; crosscut into 24 squares, each 6⅞" x 6⅞"; cut once diagonally for a total of 48 dark triangles
- 13 strips, each 2⅞" wide; crosscut into 168 squares, each 2⅞" x 2⅞"; cut once diagonally for a total of 336 triangles
- 2 strips, each 2¼" wide; crosscut into 16 rectangles, each 2¼" x 4"
- 11 strips, each 2" wide; crosscut into 122 rectangles, each 2" x 3½"

From the light solid for inner border, cut:
- 4 strips, each 1¼" wide
- 3 strips, each 1½" wide

From the light print for outer border and binding, cut:
- 7 strips, each 4½" wide, for outer border
- 7 strips, each 2¾" wide, for binding

Making the Blocks

From your fabric assortment, choose 1 light and 1 medium or dark print for each block. As you assemble them into blocks, vary the positions of the light, dark, and medium fabrics for a random, scrappy look.

1. With right sides together, sew a small dark or medium triangle to a small light triangle. Make 4 half-square triangle units. Press the seam toward the darker triangle. Sew 1 small light triangle to 1 half-square triangle unit. Press the seam toward the triangle.

Make 4. Make 1.

2. Add a dark and a light triangle to 2 of the remaining half-square triangle units from step 1 and press the seams toward the darker triangles. Add a dark triangle to the remaining triangle square. Take care to position the triangles as shown.

Make 2. Make 1.

3. Arrange the units from steps 1 and 2 as shown and sew together. Press the seams in one direction.

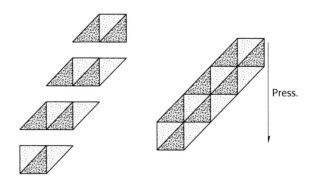

Press.

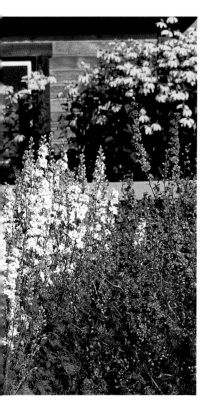

4. Sew 1 large light triangle and 1 large dark or medium triangle to the pieced unit from step 3. Press toward the triangles.

5. Repeat steps 1–4 to make a total of 48 Path through the Woods blocks. Block will measure 8½".

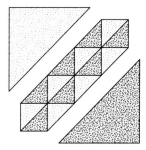 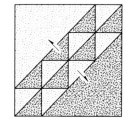

Make 48.

Assembling the Quilt Top

1. With the dark corners of the blocks meeting in the center, sew 4 blocks together to make a 4-block unit. Make 6. Repeat with the remaining blocks, positioning so the light corners of the blocks meet in the center. Block will measure 16½".

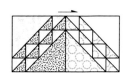

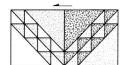

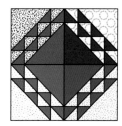 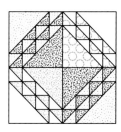

Make 6 with light centers.　　Make 6 with dark centers.

2. Referring to the quilt photo on page 26, arrange the 4-block units in 4 rows of 3 units each, with light and dark alternating from row to row and within each row. When you are pleased with the arrangement, sew the units together in rows, pressing the seams in opposite directions from row to row.

3. Sew the rows together and press the seams in one direction. Quilt top will measure 48½" x 64½".

Adding the Borders

1. Cut 1 light 1½"-wide inner border strip in half and sew a half strip to each of 2 remaining inner border strips. Trim both to measure 48½". Sew to the top and bottom edges of the quilt top.

2. Sew the four 1¼"-wide inner border strips together in pairs. Trim both to measure 66½". Sew to the quilt sides.

3. For the flying-geese border, position a 2" light square, right side down, at one end of a 2" x 3½" dark or light rectangle. Draw a light pencil line diagonally from corner to corner on the square. Stitch on the line and cut away the corner ¼" from the stitching. Press toward the triangle. Repeat at the other end of the rectangle. Using a variety of light, medium, and dark rectangles, repeat for a total of 152 flying-geese units.

Make 152
assorted light and dark.

4. With all "geese" pointing in the same direction, arrange and sew 33 flying-geese units together for the top border. Repeat for the bottom border. Sew 44 flying-geese units together for each side border. Check the border strips against the outer edge of the quilt top to make sure they will fit. Check again and if necessary take slightly narrower or larger seams along the border strips to make them fit.

5. Repeat steps 1 and 2 to prepare the outer border strips and trim to size to match the lengths of the flying-geese border strips. (The top and bottom borders will be 48½" long; the side borders will be 66½" long.)

6. Sew an outer border strip to each flying-geese border strip and press the seam toward the outer border strip in each unit. Sew the top and bottom borders to the quilt top. Press the seam toward the borders.

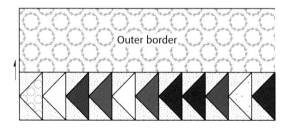

7. Make 16 flying-geese units as directed above, using 2¼" light print squares and 2¼" x 4" dark rectangles. Add a 2¼" x 4" light rectangle to the "nose" of the goose in each unit. Press the seam toward the rectangle.

Make 16.

8. For each corner block, arrange 4 flying-geese units, pinwheel style. Sew together in pairs and press seams in opposite directions. Sew the pairs together. Press.

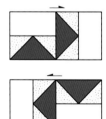

Make 4 corner blocks.

9. Sew the corner squares to opposite ends of each side border. Press the seams toward the corner squares. Sew the borders to the sides of the quilt top.

Finishing Your Quilt

Refer to the "General Directions," beginning on page 117, for specific directions in each of the following finishing steps.

1. Layer the quilt top with batting and backing; baste.

2. Machine or hand quilt as desired.

3. Trim the batting and backing even with the quilt-top edges.

4. Sew the 2¾"-wide binding strips together into one long strip and bind the quilt.

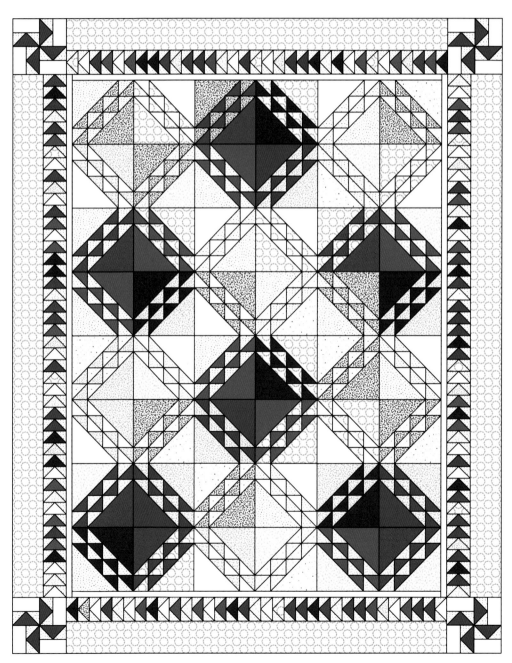

Quilt Plan

Drying Flowers

DRYING FLOWERS doesn't have to be complicated. In fact, it's really quite simple—just pick the gorgeous blooms from your garden, hang them to dry, and enjoy their beauty long after summer ends.

Larkspur, delphinium, roses, and peonies are some of the traditional dried favorites, but consider mixing in a touch of the unexpected. Try seedpods, herbs, berries, or branches with leaves for added texture.

The easiest way to dry fresh flowers is to cut them with long stems, bundle a few together with a rubber band, and hang them upside down to dry in a warm place with no sunlight. Attics or garages work well, but keep them away from sunny windows. When your fresh garden blooms are gone for the year, gather up your dried treasures and bring them indoors. What could be easier?

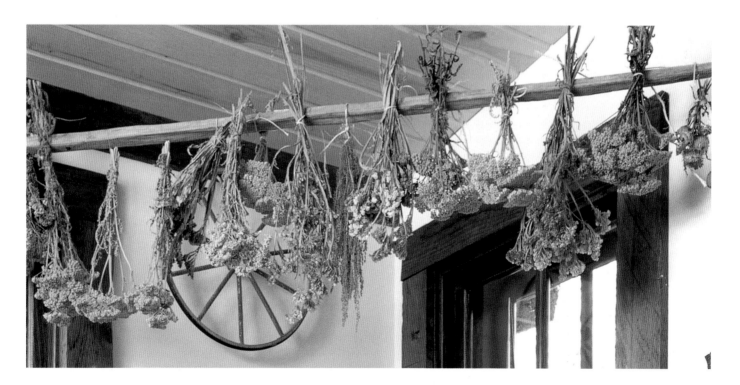

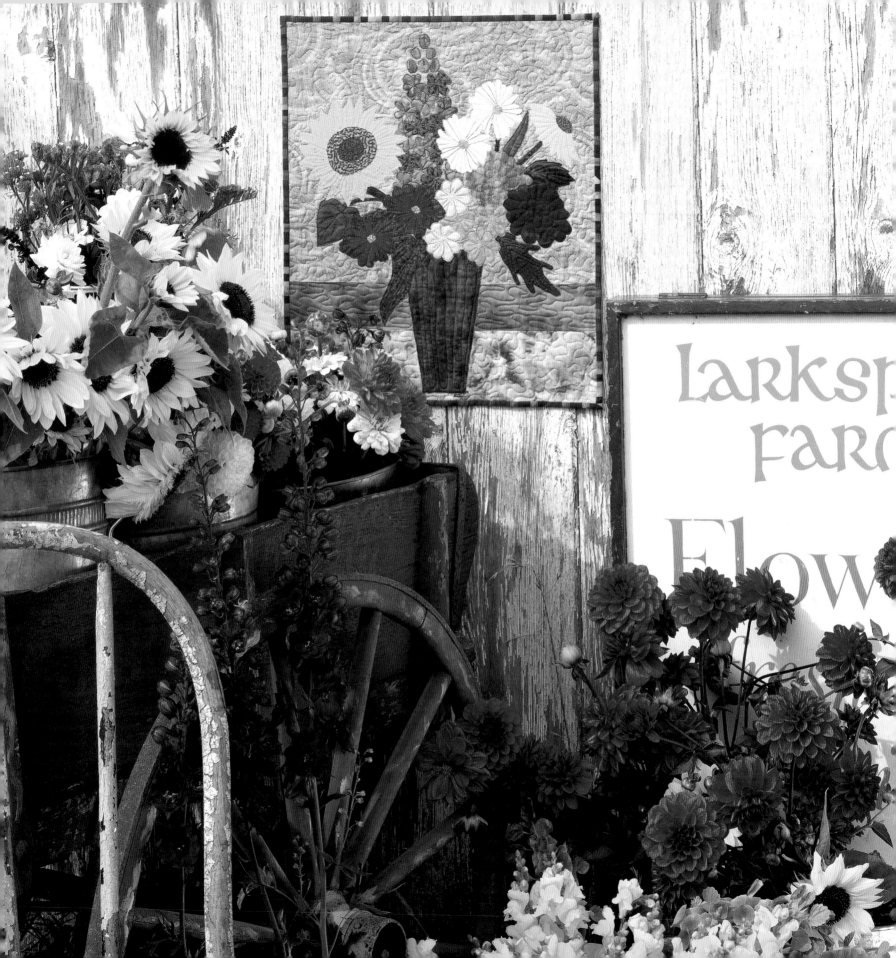

Fresh Forever

You're on your honor—just choose your favorite lovely garden bouquet from the rack and put a few

dollars in the box! Flowers are picked fresh each morning at Larkspur Farm for passersby to enjoy.

The "Flowers for Sale" stand, with its nostalgic style, is always a favorite of visitors to Larkspur Farm.

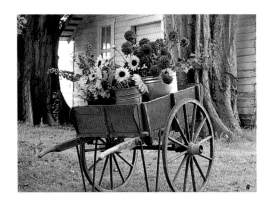

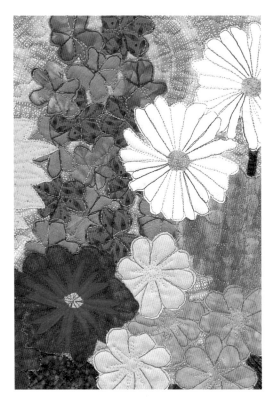

Materials

All yardage is based on 42"-wide fabric unless otherwise stated.

- 1 fat quarter of medium green print for background
- ⅛ yd. of medium dark green print for background
- ⅙ yd. of medium light green print for background
- 6" x 12" piece of black print for vase
- Scraps of green fabrics for leaves and stems
- Scraps of 3 different lavender fabrics for larkspur
- Scraps of yellow and brown for sunflower
- Scraps of white and gold for daisies

- Scraps of orange and red for zinnias
- Scraps of yellow and brown for gaillardia
- Scraps of pink and salmon for phlox
- Scraps of purple and red for petunias
- ⅝ yd. for backing
- ⅙ yd. for binding
- 19" x 21" piece of cotton batting
- Tissue or tracing paper
- Basting glue
- Masking tape
- Safety pins, size #1
- Darning presser foot
- Threads to match or contrast with the flowers and background
- Topstitching or metallic needle

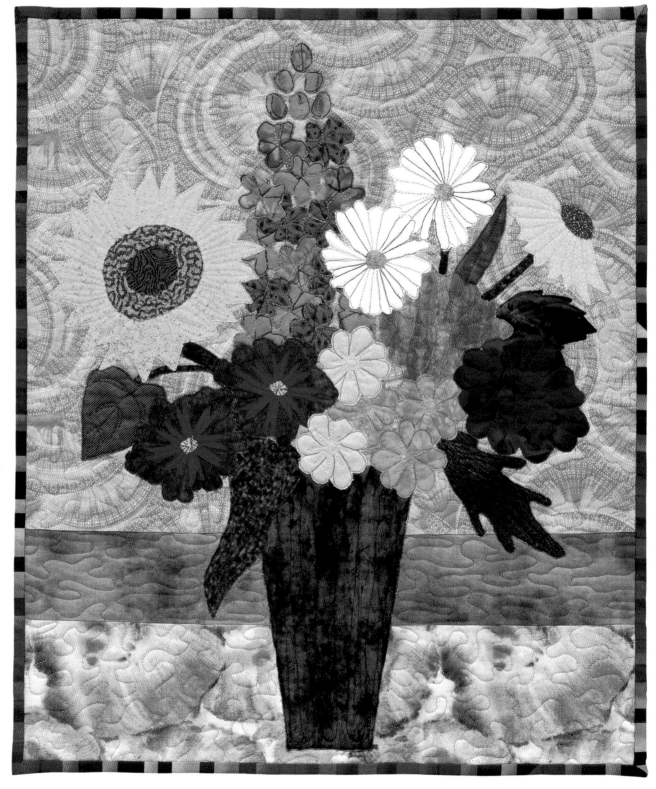

Fresh Forever
By Jean Van Bockel, 2001, Coeur d'Alene, Idaho, 18" x 21".

Cutting

Cut all strips across the fabric width. All measurements include ¼"-wide seam allowances.

From the medium green fat quarter, cut:
- 1 rectangle, 15" x 18"

From the medium dark green fabric, cut:
- 1 strip, 3" x 18"

From the medium light green fabric, cut:
- 1 strip, 4½" x 18"

From the backing fabric, cut:
- 1 rectangle, 19" x 22"

From the binding fabric, cut:
- 2 strips, each 2" x 40"

Arranging the Bouquet

Use the full-size appliqué patterns on pages 37–39.

1. Sew the narrow, medium dark green strip between the medium green rectangle and the medium light green strip. Press the seams open.

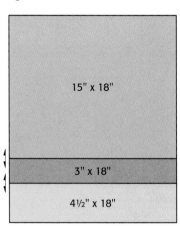

15" x 18"

3" x 18"

4½" x 18"

Pieced Background Panel
Press seams open.

2. Trace the appliqué shapes onto tissue or tracing paper and cut out on the traced lines. Use as patterns to cut the shapes from the appropriate fabrics. *Do not add turn-under allowances.* You will machine quilt all raw-edge appliqués in place with free-motion quilting.

3. Fold the vase and background panel in half lengthwise and lightly crease. Use the fold lines as guides to center the vase on the background panel, placing the bottom edge of the vase 1½" from the lower raw edge of the background panel.

4. Refer to the quilt photo for flower and leaf placement. Arrange the appliqués to look like a real flower arrangement, striving for an original look to your bouquet rather than a carbon copy of our arrangement. It's not necessary to use all of the flowers you've cut—and you can add more if you wish. Change colors or add other favorite flowers. Have fun—this arrangement will stay fresh forever!

5. Cut strips for stems (¼" wide for smaller flowers and ½" wide for the sunflower) and add where needed.

6. When you are satisfied with your arrangement, use small dabs of basting glue to hold appliqués in place on the pieced background.

Free-Motion Quilting

1. Smooth the backing fabric, right side down, on a flat surface and use masking tape to secure to the work surface. Add a layer of cotton batting, smoothing out any wrinkles. Add the quilt top, right side up, smooth in place, and pin-baste the layers together, spacing safety pins 3" to 4" apart throughout.

2. Attach the darning presser foot to your machine and lower the feed dogs for free-motion quilting.

3. Choose quilting threads to enhance and embellish your flowers. Experiment with rayon and metallic threads for added sheen and sparkle. You may need to adjust thread tensions to accommodate them for best stitching results. Test on scraps of fabric with a layer of batting between.

4. The dotted lines on the flower and leaf patterns are suggested quilting lines. Try to draw with your needle, adding the petal shapes and veins to the leaves. Begin free-motion quilting in the center of the quilt and work outward. To start, take 1 stitch and pull the bobbin thread to the top. Hold the 2 threads off to one side and do a couple of stitches in place. As you start to move away, trim the threads at fabric level. End by stitching in place. Clip the thread close to the quilt front and back. Try stipple quilting the background in large looping swirls, with horizontal stippling in the center strip for a textural contrast.

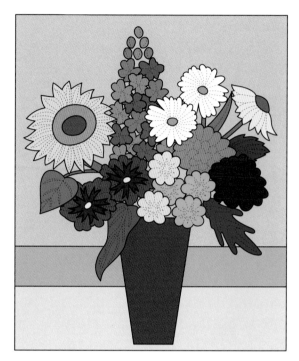

Quilt Plan

NOTE: I used a large stipple stitch for the background of the quilt, reversing the direction and scaling down the size in the middle strip for textural variation. The vase was done in large vertical loops for a linear feeling.

Finishing Your Quilt

1. Trim the excess batting and backing even with the quilt-top edges, squaring up as needed. (Free-motion quilting tends to draw in the layers and distort the corners.)

2. Sew the 2"-wide binding strips together into one long strip and bind the quilt (see "Binding" on page 122).

Appliqué Patterns

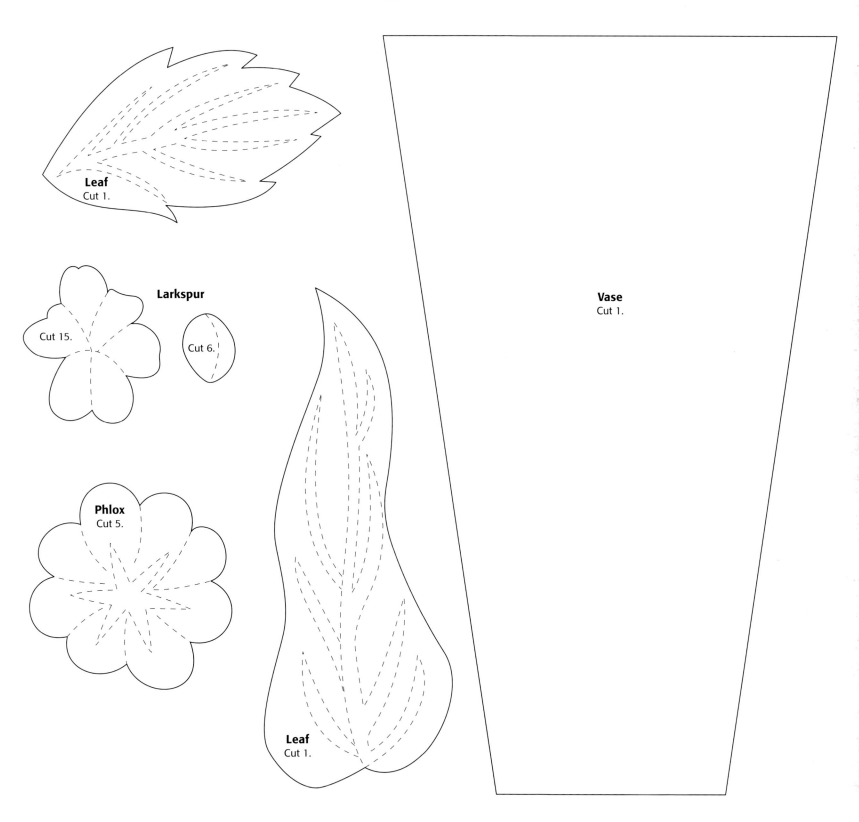

Leaf
Cut 1.

Larkspur

Cut 15.

Cut 6.

Phlox
Cut 5.

Leaf
Cut 1.

Vase
Cut 1.

Appliqué Patterns

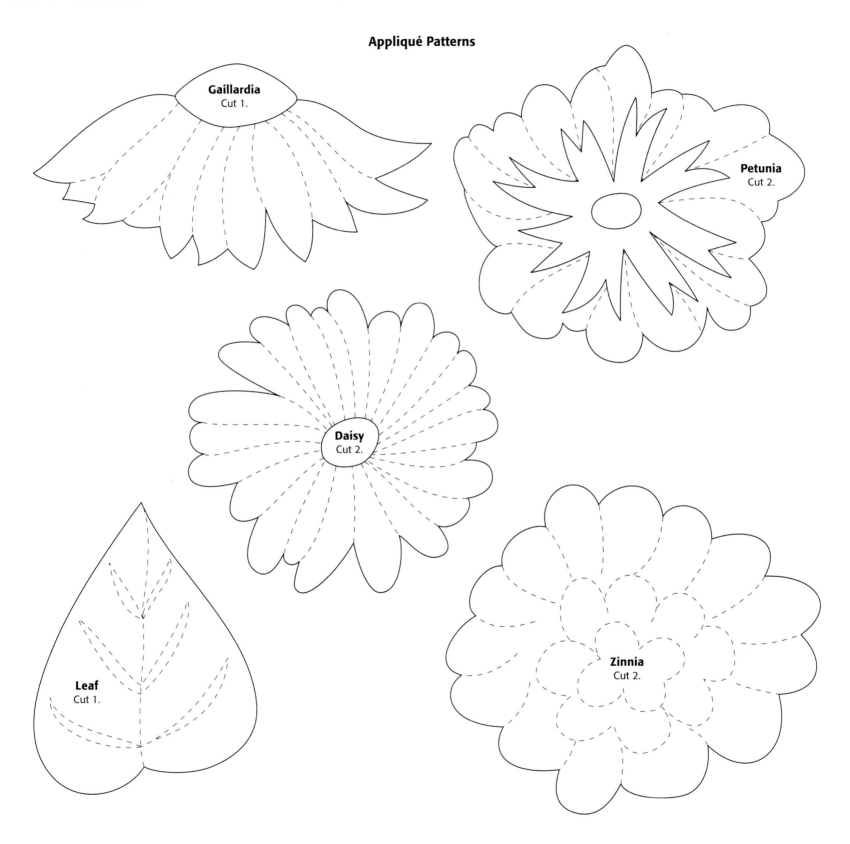

Gaillardia
Cut 1.

Petunia
Cut 2.

Daisy
Cut 2.

Leaf
Cut 1.

Zinnia
Cut 2.

Appliqué Patterns

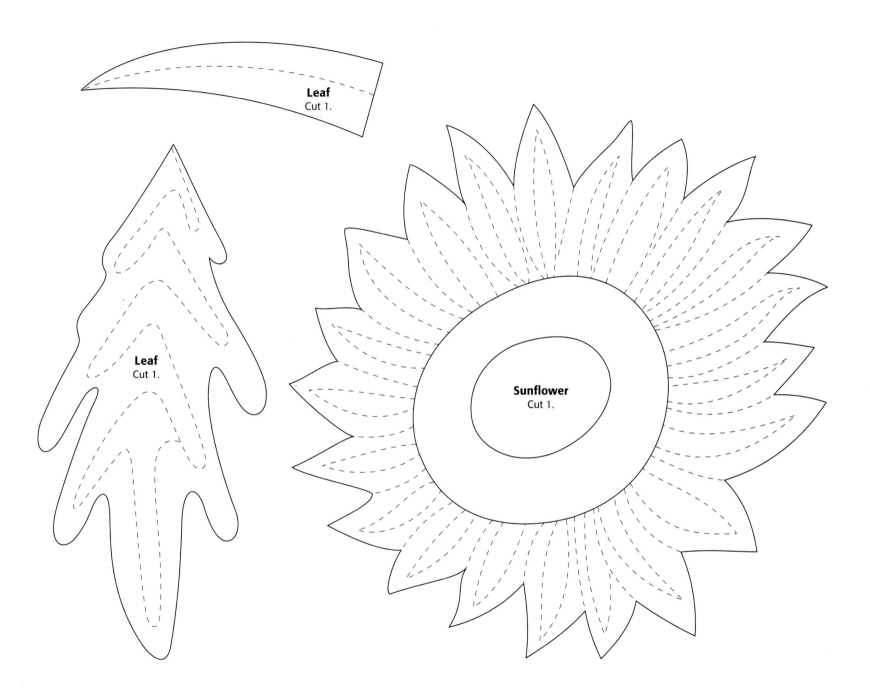

Leaf
Cut 1.

Leaf
Cut 1.

Sunflower
Cut 1.

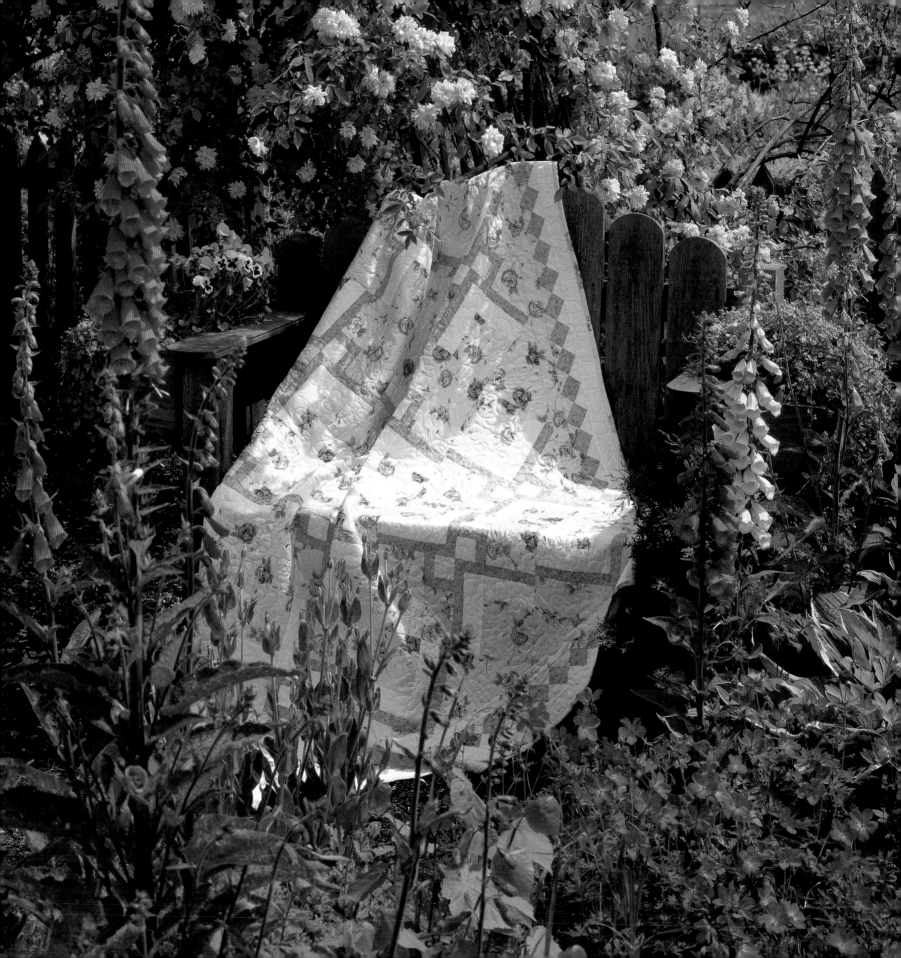

Roses for the Bride

A cascade of enchanting roses greets the bride who chooses this delightful garden spot at Larkspur Farm

for a summer wedding. Bless a favorite couple with this bridal quilt covered in roses,

like those in the fragrant gardens at the farm.

Materials

All yardage is based on 42"-wide fabric unless otherwise stated.

- 1⅛ yds. light green print for blocks and Seminole border
- 1¾ yds. white for background and border
- 3 yds. light rose print for blocks, side setting and corner triangles, and border
- 3¾ yds. for backing
- ⅔ yd. for binding
- 64" x 86" piece of batting

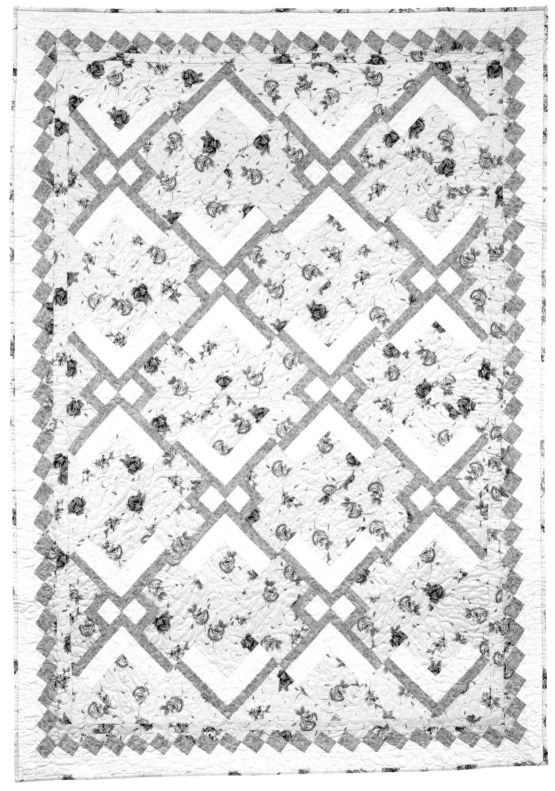

Roses for the Bride
By Pamela Mostek, 2000, Cheney, Washington, 56" x 78".

Cutting

Cut all strips across the fabric width. All measurements include ¼"-wide seam allowances.

From the light green print, cut:

- 13 strips, each 1½" wide; crosscut into:

 24 rectangles, each
 1½" x 7½"

 24 rectangles, each
 1½" x 8½"

 20 rectangles, each
 1½" x 2½"

 20 rectangles, each
 1½" x 3½"

- 5 strips, each 2½" wide

From the white fabric, cut:

- 23 strips, each 2½" wide; set 7 strips aside for the outer borders and set 5 strips aside for the Seminole pieced borders. From the remaining 11 strips, cut the following pieces:

 24 rectangles, each 2½" x 5½"
 24 rectangles, each 2½" x 7½"
 20 squares, each 2½" x 2½"
 2 rectangles, each 2" x 2½"

- 6 rectangles, each 2" x 6½"

From the light rose print, cut:

- 3 strips, each 1½" wide
- 5 strips, each 2½" wide
- 10 strips, each 5½" wide; crosscut into:

 24 squares, each 5½" x 5½"
 20 rectangles, each 3½" x 5½"
 20 rectangles, each 5½" x 8½"
 2 rectangles, each 2" x 6½"

- 1 strip, 12⅝" wide; crosscut into 3 squares, each 12⅝" x 12⅝"; cut twice diagonally for a total of 12 side setting triangles
- 1 strip, 6⅝" wide; crosscut into 2 squares, each 6⅝" x 6⅝"; cut once diagonally for a total of 4 corner triangles
- 4 strips, each 2" wide

From the binding fabric, cut:

- 7 strips, each 2¾" wide

Making Block A

1. Using a 2½" x 5½" white rectangle, a 5½" light rose print square, a 2½" x 7½" white rectangle, a 1½" x 7½" light green print strip, and a 1½" x 8½" light green print strip, arrange the pieces for the block and sew together in numerical order. Press in the direction of the arrows after adding each strip.

2. Repeat step 1 to make 24 of Block A.

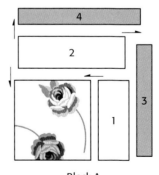

Block A
Make 24.

Making Block B

1. Using a 1½" x 2½" light green print rectangle, a 2½" white square, a 1½" x 3½" light green print rectangle, and a 3½" x 5½" light rose print rectangle, arrange and sew the pieces together as shown. Press in the direction of the arrows after adding each piece.

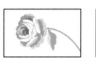

2. Sew a 5½" x 8½" light rose print rectangle to the top edge of the unit from step 1 to complete Block B. Press the seam toward the rectangle.

Block B
Make 20.

3. Repeat steps 1 and 2 to make a total of 20 Block B.
4. Cut 5 of Block B in half diagonally as shown for the pieced side setting triangles. Discard the cutaways.

Discard.

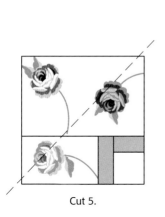
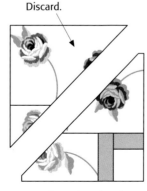

Cut 5. Side setting triangle

Assembling the Quilt Top

1. Arrange Blocks A and B in 9 rows as shown in the layout, adding Block B halves, 11 light rose print side setting triangles, and 2 light rose print corner triangles where indicated. You will add the remaining 2 corner triangles after assembling the rows. Sew the blocks and triangles together in rows. Press the seams toward Block B and the side and corner setting triangles in each row.

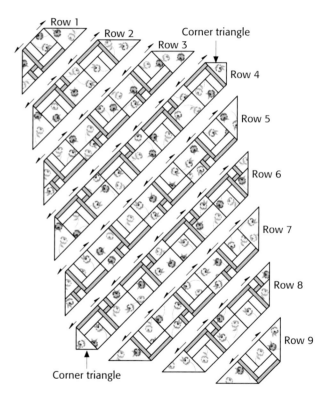

Row 1
Row 2
Corner triangle
Row 3
Row 4
Row 5
Row 6
Row 7
Row 8
Row 9
Corner triangle

2. Sew the rows together and add the 2 remaining light rose print triangles to opposite corners of the quilt top. Press the seams toward the triangles.
3. Cut 1 light rose print 1½"-wide strip in half and sew a half strip to 2 of the remaining 1½"-wide light rose print strips. Measure the width of the quilt top through the center and trim the strips to match (approx. 46½"). Sew to the top and bottom edges of the quilt top. Press the seams toward the borders.

4. Sew the remaining 2"-wide light rose print strips together in pairs. Measure the length of the quilt top through the center and trim the strips to match (approx. 69½"). Sew to the sides of the quilt top. Press.

Making the Seminole Borders

1. Join 1 white strip, 1 light green print strip, and 1 light rose print strip, each 2½" wide, in the order shown. Press seams toward the green strip. Repeat to make a total of 5 strip sets. Cut the strip sets into 2"-wide segments. You will need a total of 98 segments.

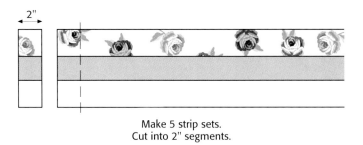

Make 5 strip sets.
Cut into 2" segments.

2. On 2 segments, remove the rose square and replace it with a 2" x 2½" piece cut from scraps of white fabric. Reserve these 2 segments for the side borders.

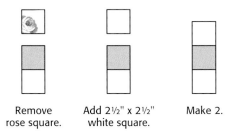

Remove Add 2½" x 2½" Make 2.
rose square. white square.

3. Staggering the segments as shown, sew 19 segments together for the top border and 19 for the bottom border. Add a white 2" x 6½" rectangle to one end of each strip and a 2" x 6½" light rose print rectangle to the opposite end, staggering as shown. Press seams in one direction.

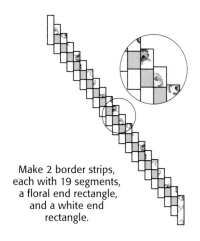

Make 2 border strips,
each with 19 segments,
a floral end rectangle,
and a white end
rectangle.

4. Arrange the remaining segments into strips of 30 segments each, using one of the adjusted segments from step 2 at one end of each strip. Sew the segments together and add a 2" x 6½" white rectangle to each end to complete the side border strips. Press seams in one direction.

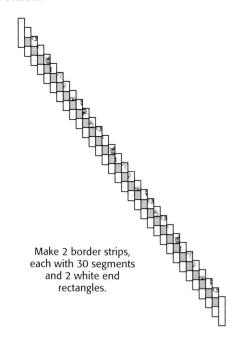

Make 2 border strips,
each with 30 segments
and 2 white end
rectangles.

5. Using a see-through ruler and rotary cutter, carefully trim the top and bottom of the strips as shown, leaving a *generous* ¼"-wide seam allowance at each edge.

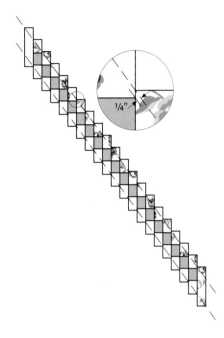

6. With right sides together and the light rose print triangles next to the quilt top, sew the shorter pieced border strips to the top and bottom edges of the quilt top. You may find it necessary to adjust the border lengths to fit the quilt top by taking slightly narrower or deeper seams. It is a good idea to measure the quilt top length and width through the center and check the border strip lengths. Sew the borders to the quilt top and press the seams toward the quilt-top center. Sew the remaining pieced strips to the sides of the quilt in the same manner, adjusting the length if necessary. Press.

7. Cut 1 white border strip, 2½" wide, in half and sew to the ends of 2 other white border strips. Measure the width of the quilt top through the center and trim the strips to match (approx. 54½"). Sew to the top and bottom edges of the quilt top. Press the seams toward the white border.

8. Sew the 4 remaining white border strips together in pairs. Measure the length of the quilt top through the center and trim each strip to match (approx. 74½"). Sew to the quilt sides. Press.

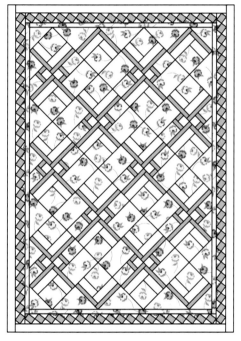

Quilt Plan

Finishing Your Quilt

Refer to the "General Directions," beginning on page 117, for specific directions in each of the following finishing steps.

1. Layer the quilt top with batting and backing; baste.

2. Machine or hand quilt as desired.

3. Trim the batting and backing even with the quilt-top edges.

4. Sew the 2¾"-wide binding strips together into one long strip and bind the quilt.

Rose Ice Bucket

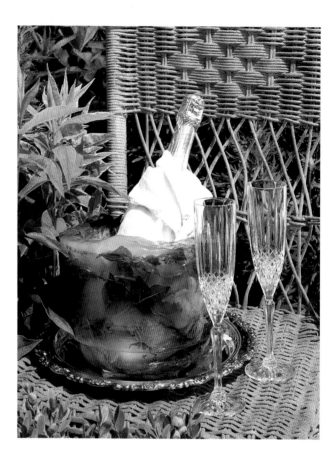

*I*T'S TRULY MAGNIFICENT! Gracing the table at weddings of family and friends, this rose ice bucket, made by Pam (or her mother), has been a festive tradition in her family for years.

It's not difficult to make one for your own celebration. Here's what you'll need:

- 2 containers—one about the size to hold a champagne bottle and the second large enough to hold the first container with 4" of extra room all around
- Plastic bag large enough to line the smaller container
- 1 brick
- Heavy tape, such as duct tape
- Enough dried beans to fill the small container
- Your favorite fresh flowers and leaves from the garden

Follow these steps to make the ice bucket:

1. Add about 4" of water to the large container and freeze.
2. Carefully center the smaller container on the ice inside the larger container.
3. Line the smaller container with the large plastic bag, put a brick in the bottom, and fill with dried beans. Tape across the top to hold the inner bucket firmly in place.
4. Now for the fun—adding the flowers! Drop roses with their leaves—or any other favorite blossoms with their leaves—into the space between the containers. They will tend to float after you add the water, so you need to add plenty to fill the space. When the space is full, carefully add enough water to reach the top edge of the small container, taking care not to get any water inside the small container.
5. Place in the freezer until your gorgeous ice bucket is firmly frozen. Several times during the freezing, use a long handled spoon to push the flowers toward the bottom.
6. To remove the ice bucket, take it from the freezer and remove the sack with the beans and brick. Remove the smaller container after the ice has begun to melt slightly. To speed up the process, you may add cool water to the smaller container. Remove the outside container as soon as possible.
7. Wrap the ice bucket in a large plastic bag and refreeze until the big day! Simply gorgeous!

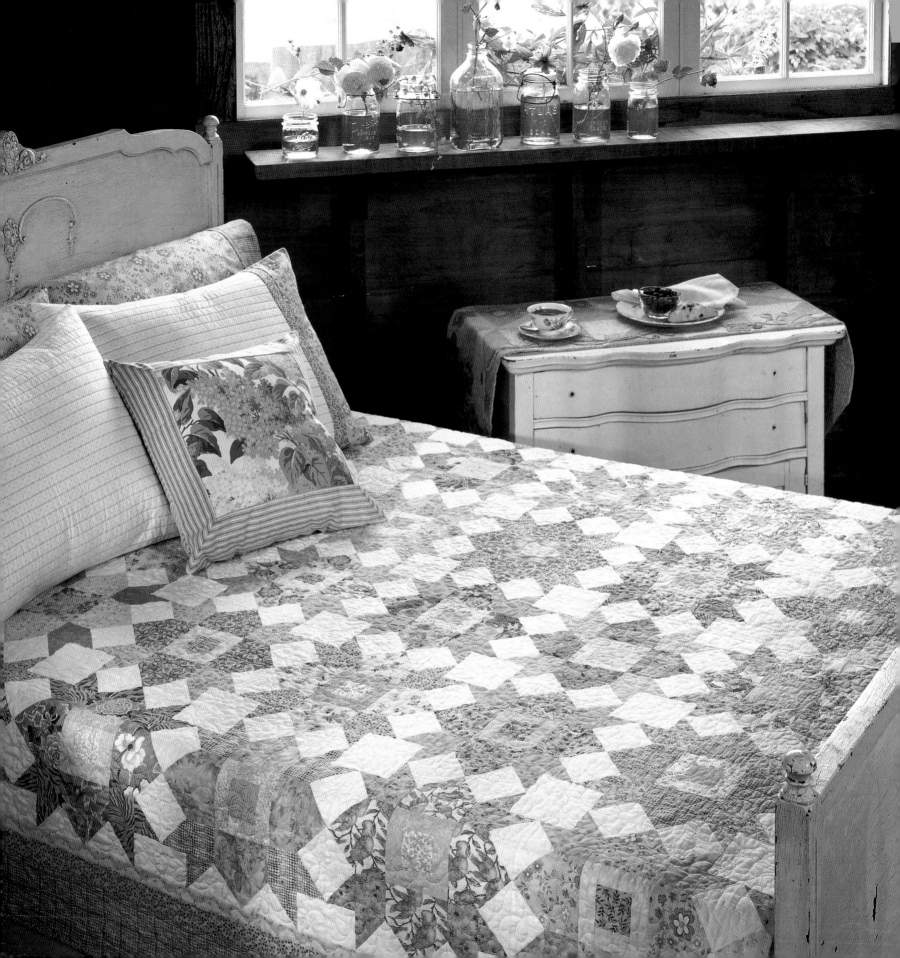

Pressed Flowers

The Garden House at Larkspur Farm is a charming "antique," where overnight guests are greeted with the morning sunshine peeking through the wall boards! Cherished pieces of pottery and china grace the room, and an antique white bed and dresser create a charming look of vintage elegance. We've added the perfect finishing touches—a softly colored quilt and pillow covers, with an ivy-strewn dresser scarf in lovely garden pastels.

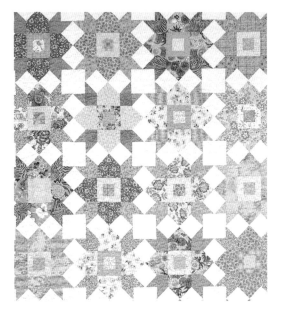

Materials

All yardage is based on 42"-wide fabric unless otherwise stated.

- 3½ yds. light print for block backgrounds
- 2¼ yds. assorted green prints for leaves
- ⅓ yd. each of 11 floral fabrics for flowers
- ¾ yd. assorted prints for inner flower accent strips
- ¼ yd. assorted prints for flower centers
- ½ yd. yellow for inner border
- ⅝ yd. green for middle border
- 1½ yds. plaid for outer border
- 8 yds. for backing
- ⅔ yd. for binding
- 92" x 104" piece of batting

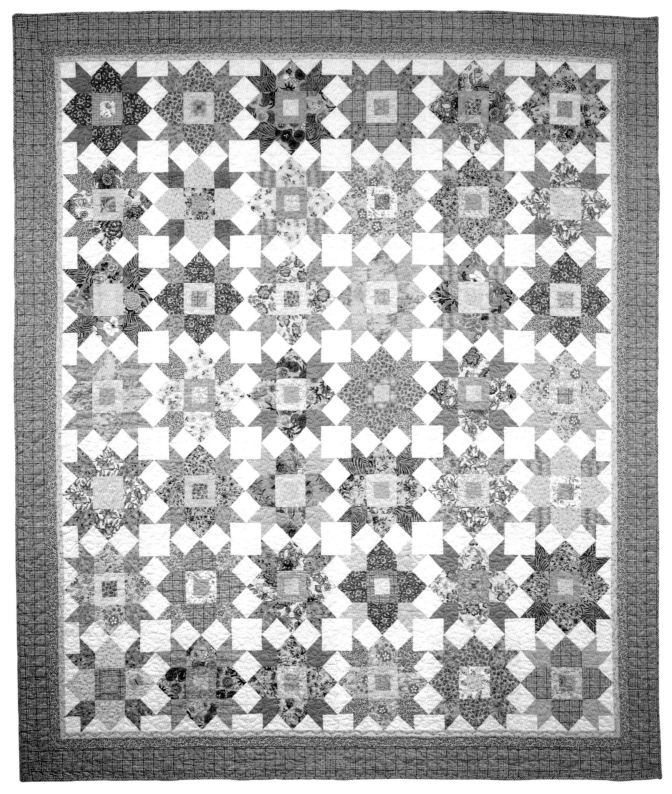

Pressed Flowers
By Jean Van Bockel, 2000, Coeur d'Alene, Idaho, 84" x 96".

Cutting

Cut all strips across the fabric width. All measurements include ¼"-wide seam allowances.

From the light background fabric, cut:
- 32 strips, each 2½" wide; crosscut into 504 squares, each 2½" x 2½"
- 13 strips, each 2⅞" wide; crosscut into 168 squares, each 2⅞" x 2⅞"; cut once diagonally for a total of 336 triangles

From the assorted green prints, cut:
- 168 squares, each 2⅞" x 2⅞"; cut once diagonally for a total of 336 triangles
- 168 squares, each 2½" x 2½"

From each of the 11 floral fabrics, cut:
- 2 strips, each 4½" wide; crosscut each strip into 8 squares, each 4½" x 4½", for a total of 176 squares (8 extra)

From the assorted prints for the inner flower accent strips, cut:*
- 84 rectangles, each 1½" x 2½"
- 84 rectangles, each 1½" x 4½"

From the assorted flower-center prints, cut:
- 42 squares, each 2½" x 2½"

From the yellow fabric, cut:
- 10 strips, each 1¼" wide, for inner border

From the green fabric, cut:
- 10 strips, each 1¾" wide, for middle border

From the plaid fabric, cut:
- 11 strips, each 4½" wide, for outer border

From the binding fabric, cut:
- 10 strips, each 2" wide

For speedy cutting, cut 1½"-wide strips from the fabrics, then cut into the required number of shorter pieces.

Making the Blocks

1. Sew a 1½" x 2½" inner flower accent rectangle to opposite sides of a 2½" flower-center square. Press seams toward the rectangles. Sew the 1½" x 4½" rectangles to the remaining edges of the center unit. Make 42.

Make 42.

2. On the wrong side of 336 of the background squares, draw a light pencil line diagonally from corner to corner. To make it easier to mark the fabric, place the squares on the gritty side of a piece of very fine–grain sandpaper so they won't slip while you draw.

3. Place each background square from step 2 on the upper left corner of a 4½" floral square. Stitch on the line and cut away the corner ¼" from the stitching. Press toward

the triangle. Add a background square to the upper right corner, trim, and press in the same manner. Make matching sets of 4 each, 1 set for each of the 42 blocks, for a total of 168 units.

Make in sets of
4 matching units
(1 set for each
of 42 blocks).

4. Add units from step 3 to opposite edges of the flower centers from step 1. Note the placement and orientation of the accent strips in the flower centers in the illustrations below. Press the seams in the direction of the arrows. Note the change in direction in each set of 21 units. This piecing and pressing method helps later in the quilt-top assembly.

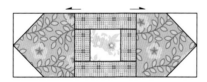

Make 21.

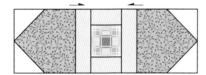

Make 21.

5. Sew each of the 336 background fabric triangles to a green print triangle. Press the

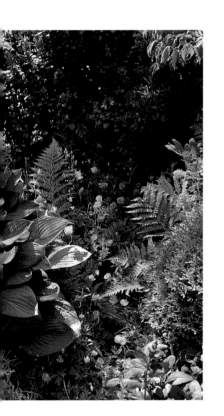

seam toward the green triangle. Make matching sets of 8 for a total of 336 pieced squares.

Make a total of
336 in sets of
8 matching-fabric units.

6. Working in sets of 4, sew an unmarked background square to the top edge of the pieced squares. Make 168. Sew a 2½" green print square to the bottom of the remaining pieced squares, taking care to orient the piecing correctly. Make 168. Press the seams toward the pieced squares in each unit.

Make 168
in sets of 4 matching-fabric units.

Make 168
in sets of 4 matching-fabric units.

7. Sew the units from step 6 together in pairs and press the seams in the direction of the arrows. Make a total of 168 leaf units.

Make 168
in matching sets of 4.

8. Working on one block at a time, arrange the pieces as shown. Sew together in rows and press in the direction of the arrows. Note that the orientation of the accent strips in the flower center determines the direction in which to press the joining seams.

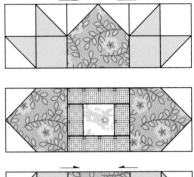

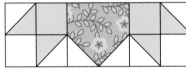

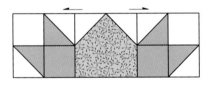

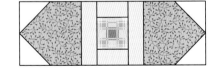

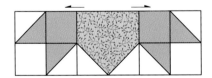

Make 21.

9. Sew the rows together for each block and press the seams in the direction of the arrows.

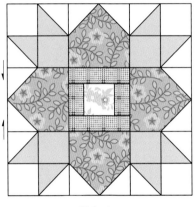

Make 21.

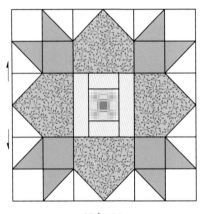

Make 21.

Assembling the Quilt Top

1. Arrange the blocks into 7 rows of 6 blocks each, positioning so that there are opposing seams for easy joining. Sew the blocks together in each row, taking care to match seams. Press the seams in opposite directions from row to row.
2. Sew the rows together. Press.
3. Sew the yellow inner border strips together in pairs to make 2 strips that are 86" long and 2 that are 98" long. Repeat with the green and plaid border strips.

4. Sew the border strips together in order (green in the middle) and press the seams toward the plaid border. See quilt plan on facing page.
5. Sew the borders to the quilt top and miter the corners as shown for mitered borders on pages 120–121.

Finishing Your Quilt

Refer to the "General Directions," beginning on page 117, for specific directions in each of the following finishing steps.

1. Divide the backing into three $2\frac{5}{8}$-yard lengths. Sew the pieces together at the long edges and press the seams open. The seams will run across the width of the finished quilt.
2. Layer the quilt top with batting and backing; baste.
3. Hand or machine quilt as desired.
4. Trim the batting and backing even with the quilt-top edges.
5. Sew the 2"-wide binding strips together into one long strip and bind the quilt.

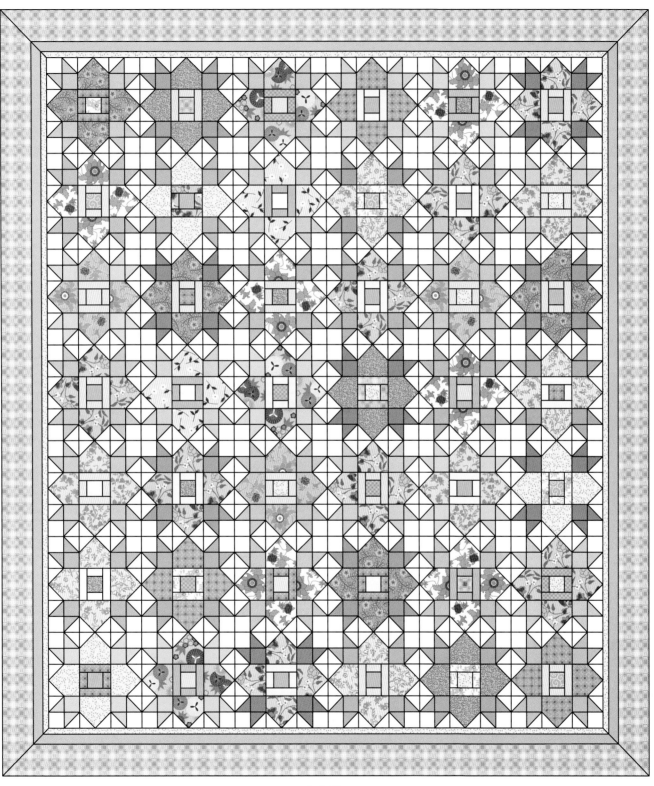

Quilt Plan

Garden House Dresser Scarf

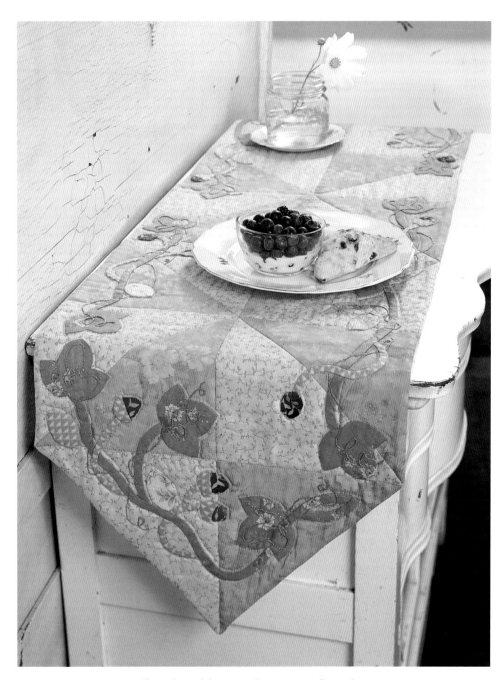

Garden House Dresser Scarf
By Pamela Mostek, 2001,
Cheney, Washington, 15" x 64".

Materials

All yardage is based on 42"-wide fabric unless otherwise stated.

- ⅝ yd. light peach fabric for blocks
- ⅝ yd. peach fabric for blocks
- ⅔ yd. green for vines
- 1⅞ yds. for backing
- Assorted green and purple scraps for leaves and buds
- 20" x 68" piece of lightweight batting
- Green pearl cotton thread
- ¼"- and ⅜"-wide bias bars (see page 119)

Cutting

Cut all strips across the fabric width. All measurements include ¼"-wide seam allowances.

From the light peach fabric, cut:

- 2 strips, each 8⅜" wide; crosscut into 7 squares, each 8⅜" x 8⅜"; cut once diagonally for a total of 14 triangles

From the peach fabric, cut:

- 2 strips, each 8⅜" wide; crosscut into 7 squares, each 8⅜" x 8⅜"; cut once diagonally for a total of 14 triangles

Piecing the Dresser Scarf

1. With right sides together, sew an 8⅜" light peach triangle to a peach triangle. Make 12 half-square triangle units. Press the seams open. Sew the remaining 4 triangles together in pairs along a short edge to create 2 large triangles for the points. Press the seams open.

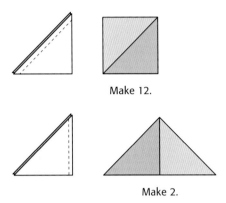

Make 12.

Make 2.

2. Sew the squares together in sets of 4 to make 3 pinwheel blocks; press in the direction of the arrows.

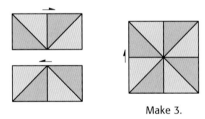

Make 3.

3. Sew the pinwheels together and press. Add a pieced point to each end of the dresser scarf. Press the seams open.

Appliquéing the Dresser Scarf

Use templates made with the patterns on page 58.

1. Using the ⅔ yard of green fabric, cut 200" of 1⅜"-wide *bias* strips (see "Bias Binding" on page 124). Use bias bars to make ⅜" bias tubes for the vines and ¼" bias tubes for the stems (see "Appliqué Vines" on page 119). Position them on the pieced background as shown in the placement guide. Hand appliqué in place (see "Appliqué Stitch" on page 119).

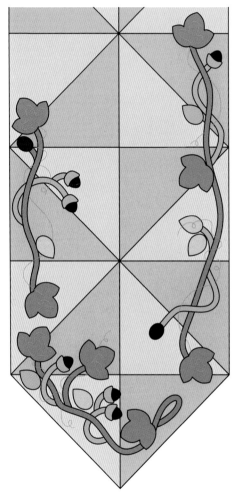

Appliqué Placement Guide

2. Using your favorite appliqué method (see "Appliquéing" on pages 117–119) and the green and purple scraps, prepare the required number of leaves and buds. Referring to the appliqué placement guide above, position the pieces on the dresser scarf and stitch in place.

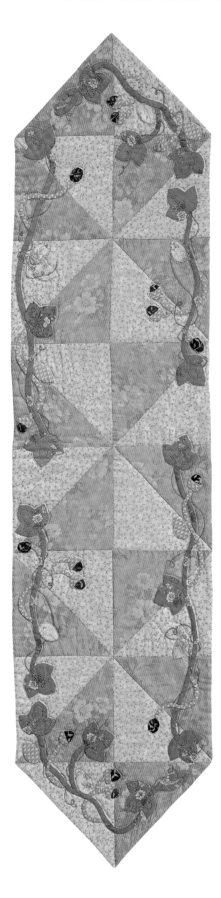

3. To embroider the tendrils on the appliqués, use pearl cotton and a stem stitch.

Stem Stitch

Finishing the Dresser Scarf

1. Cut backing the same size as the batting (20" x 68"). Place the backing, right side up, on top of the batting. With right sides together, position the dresser scarf on the backing. Pin the layers. Using the outside edge of the scarf top as a guide and a scant ¼"-wide seam allowance, stitch the layers together. Leave a 6" to 8" opening in one long edge for turning.

2. Turn right side out and press lightly from the back of the dresser scarf. Hand stitch the opening closed.

3. Quilt in the seam lines between blocks and along the diagonal seams of the triangles. Quilt ⅛" from the finished edges of the appliqués.

Appliqué Patterns

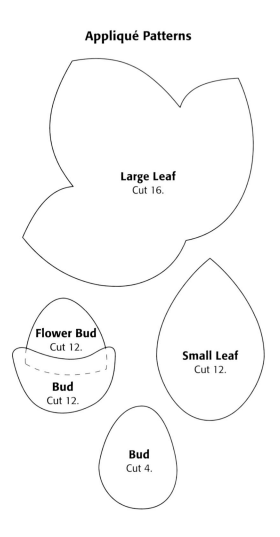

Large Leaf
Cut 16.

Flower Bud
Cut 12.

Bud
Cut 12.

Small Leaf
Cut 12.

Bud
Cut 4.

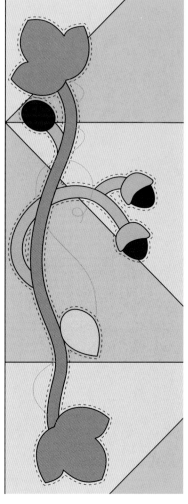

Quilt ⅛" from appliqué edges.

Garden House Pillow Cover

Garden House Pillow Cover
By Jean Van Bockel, 2001,
Coeur d'Alene, Idaho, 26" x 20".

Materials

All yardage is based on 42"-wide fabric unless otherwise stated. For each pillow cover, you will need:

- 1 yd. striped fabric for pillow cover front and back
- ⅛ yd. green print for accent strip
- ⅙ yd. pink print for band
- ⅔ yd. muslin for lining
- 21" x 27" piece of batting
- Standard bed-size pillow
- Safety pins
- Walking or even-feed foot (for quilting)

Cutting

Cut all strips across the width of the fabric. All measurements include ¼"-wide seam allowances.

From the striped fabric, cut:
- 1 piece, 20½" x 21½", with the stripes running parallel to the 21½" edges, for pillow top
- 2 pieces, each 16½" x 20½", with stripes running parallel to the 16½" edges, for pillow back

From the green print, cut:
- 1 strip, 1½" x 20½", for accent strip

From the pink print, cut:
- 1 strip, 4½" x 20½", for band

From the muslin, cut:
- 1 piece, 21" x 27", for pillow top

Making the Pillow Cover Front

1. Place the batting on top of the muslin, matching the edges. Place the 20½" x 21½" striped piece on top, right side up, with the right-hand short edge ½" from the batting edge. Baste layers together with safety pins (see "Layering the Quilt" on page 121).
2. Attach a walking foot to your machine (or engage the even-feed feature) and stitch along the center stripe from raw edge to raw edge. Repeat along each remaining stripe on each side of the center stripe.

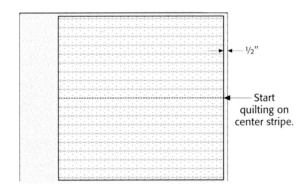

½"

Start quilting on center stripe.

3. Place the green print strip, right side down, on the left edge of the striped fabric and stitch ¼" from the raw edges through all layers. Turn the strip back over the seam and press.
4. Add and press the pink strip in the same manner. Stitch in the ditch on both sides of the green accent border.

5. On the pink band, use a pencil to lightly mark 3 lines at 1" intervals. Machine quilt on the lines.

6. Trim the pillow top to 20½" x 26½".

Finishing the Pillow Cover

1. On each 16½" x 20½" piece of striped fabric, turn under one of the 20½" edges by ¼" and press. Turn again, press, and edgestitch close to the fold.
2. With the quilted pillow top right side up on a flat surface, place the backing pieces right side down on top with raw edges even and the hemmed edges overlapping in the middle. Pin raw edges together. Stitch ¼" from the raw edges all around. Clip across the corner points, turn the completed pillow cover right side out, and press. Insert the pillow.

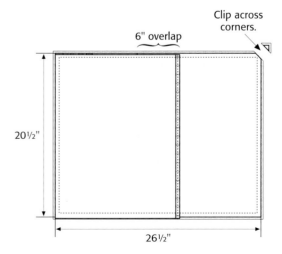

Clip across corners.

6" overlap

20½"

26½"

Garden Collecting

ISPLAYING FAVORITE TREASURES doesn't have to be reserved for the china cupboard in the dining room. The garden is a great place to display a collection, too. Of course, your garden collections should be "outdoor proof" because the warm summer sun and crisp fall breezes are part of life in the garden.

There are plenty of fun and easy-to-find collectibles that won't mind the weather and will add a delightfully unexpected touch to your garden blooms. For example, watering cans of all sizes and shapes, painted and worn from loving use, are part of the decor at Larkspur Farm. A collection of charming birdhouses, new and old, or a grouping of vintage garden tools along the fence are other ideas for adding a fanciful touch to your garden.

Finding these garden goodies is part of the fun. Antique shops, yard sales—perhaps your own garage—are great places to begin. It doesn't take much to get started—remember, it only takes three of something to call it a collection!

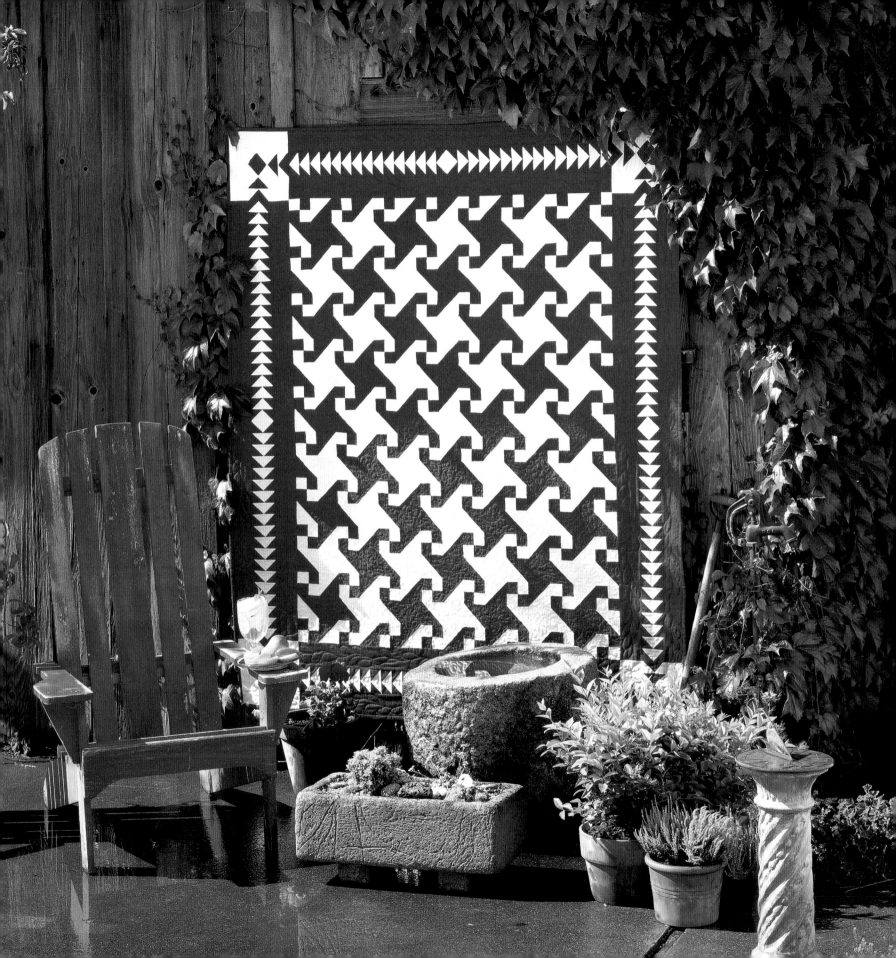

Blaze

Inspired by the brilliant red climbing roses that cover archways and trellises at Larkspur Farm,

this dramatic red-and-white quilt is just as spectacular.

Materials

All yardage is based on 42"-wide fabric unless otherwise stated.

- 5 yds. red for blocks, borders, and binding
- 3¼ yds. white for blocks and borders
- 4¼ yds. for backing
- 71" x 83" piece of batting

Cutting

Cut all strips across the fabric width. All measurements include ¼"-wide seam allowances.

From the red fabric, cut:
- 24 strips, each 2" wide; set aside 8 strips and crosscut 16 strips into:
 - 272 squares, each 2" x 2"
 - 16 rectangles, each 2" x 3½"
- 4 strips, each 3½" wide; crosscut into 36 squares, each 3½" x 3½"
- 10 strips, each 3⅞" wide; crosscut into 71 squares, each 3⅞" x 3⅞"; cut once diagonally to make a total of 142 triangles
- 11 strips, each 3½" wide, for border
- 8 strips, each 2¾" wide, for binding

From the white fabric, cut:
- 23 strips, each 2" wide; set 8 strips aside and crosscut 15 strips into:
 - 128 rectangles, each 2" x 3½"
 - 48 squares, each 2" x 2"
- 6 strips, each 3½" wide; crosscut into:
 - 39 squares, each 3½" x 3½"
 - 4 rectangles, each 3½" x 6½"
 - 4 rectangles, each 3½" x 9½"
- 10 strips, each 3⅞" wide; crosscut into 71 squares, each 3⅞" x 3⅞"; cut once diagonally for a total of 142 triangles

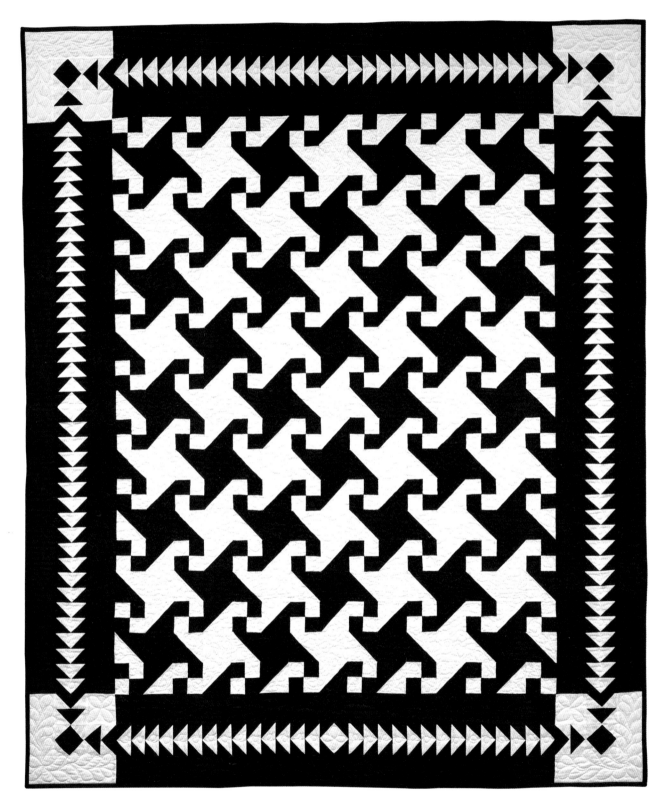

Blaze
Designed by Pamela Mostek, pieced by Edie Dobbins, 2001, Cheney, Washington, 63" x 75".

Making Four Patch and Half-Square Triangle Blocks

1. Sew 8 white 2"-wide strips and 8 red 2"-wide strips together in pairs. Press the seam toward the red strip in each strip set. Cut 160 segments, each 2" wide, from the strip sets.

Cut 160 segments.

2. Sew segments together in pairs, positioning colors as shown. Press. Make 80 Four Patch blocks.

Make 80.

3. Sew each red 3⅞" triangle to a white 3⅞" triangle along the diagonal edge, taking care not to stretch the bias edges. Make 142 half-square triangle blocks.

Make 142.

Assembling the Rows

1. Using Four Patch and half-square triangle blocks, 3½" red squares, and 3½" white squares, arrange the pieces for rows 1–4 as shown. Sew the pieces together in each row and press the seams in the direction of the arrows. Sew the rows together to make section 1 of the quilt top. Make sections 2, 3, and 4 in the same manner. To make section 5, join the remaining rows 1, 2, and 3.

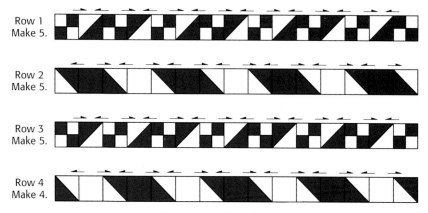

Row 1
Make 5.

Row 2
Make 5.

Row 3
Make 5.

Row 4
Make 4.

Join rows 1–4 to make sections 1–4.
Join remaining rows 1, 2, and 3 for section 5.

2. Sew all 5 sections together in order and press the seams in one direction.

Making the Flying Geese Border and Corner Blocks

1. Position a 2" red square, right side down, at one end of a 2" x 3½" white rectangle. Draw a light pencil line diagonally from corner to corner on the square. Stitch on the line and cut away the corner ¼" from the stitching. Press toward the triangle. Repeat at the other end of the rectangle. Make 128.

Make 128.

2. Make 16 flying-geese units, using 2" white squares and 2" x 3½" red rectangles; set aside for the border corner squares.

Make 16.

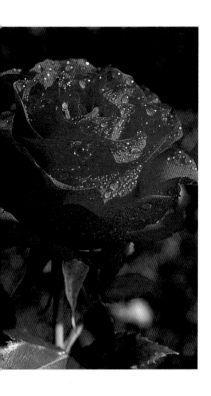

3. With all the "geese" pointing in the same direction, sew the border units into 4 strips of 18 flying-geese units each and 4 strips of 14 units each. Press all seams toward the long edge of the triangles in each strip.

4. To make diamond squares for the center of each border strip, position a 2" red square face down at opposite corners of a 3½" square. Draw a light pencil line diagonally from corner to corner. Stitch on the line and cut away the corners ¼" from the stitching. Press the seams toward the red triangles. Repeat on the remaining corners. Press. Make 4.

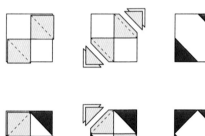

Make 4.

5. Make 4 diamond center blocks in the same manner, using 2" white squares and 3½" red squares. Set aside for the corner squares.

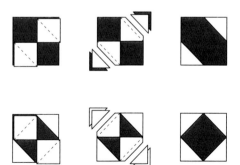

Make 4.

6. Sew each set of flying-geese borders together with a white diamond square in the center and the triangles in each strip pointing away from the center (refer to the quilt photo on page 64).

7. Arrange the remaining white rectangles and squares with the flying-geese units and diamond-square pieces as shown and sew together to make 4 corner blocks.

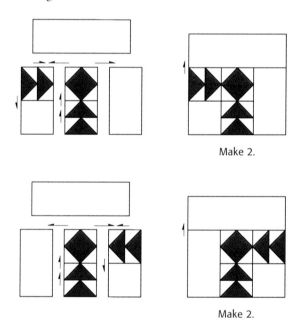

Make 2.

Make 2.

Adding the Borders

1. Cut 1 red 3½"-wide strip into 4 equal sections. Sew a section to the end of each of 4 of the remaining border strips. Measure the width of the quilt top through the center (approx. 45½") and trim the strips to match this length. Measure the length of

the shorter flying-geese borders. If they do not match the quilt-top measurement, adjust them to match by taking a few slightly deeper seams (or letting out a few seams if necessary). Sew a red border strip to each long edge of the pieced borders. Press the seams toward the red border.

2. Sew the resulting border strips to the top and bottom edges of the quilt top.

3. Repeat step 1 with the remaining red border strips, measuring, adjusting, and trimming the pieced borders as needed. (Quilt-top length should be approximately 57½".)

4. Sew corner squares to opposite ends of the border strip, positioning so the flying-geese units connect, and the white rectangles are at the outer corners of the strip. Sew the borders to the long edges of the quilt top and press seams toward the corners.

Finishing Your Quilt

Refer to the "General Directions," beginning on page 117, for specific directions in each of the following finishing steps.

1. Layer the quilt top with batting and backing; baste.

2. Machine or hand quilt as desired.

3. Trim the batting and backing even with the quilt-top edges.

4. Sew the 2¾"-wide binding strips together into one long piece and bind the quilt.

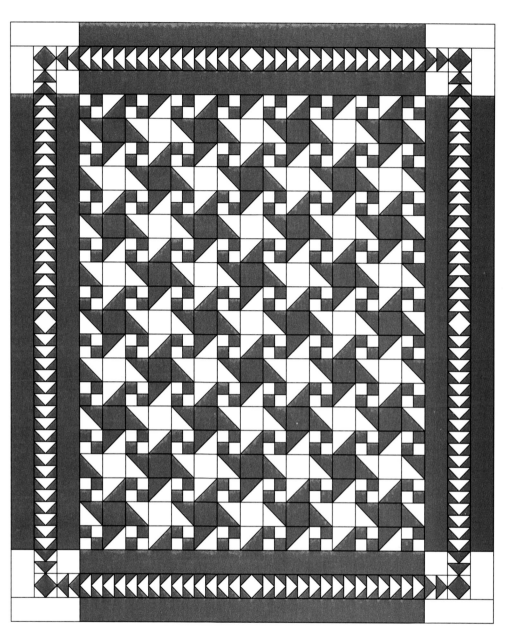

Quilt Plan

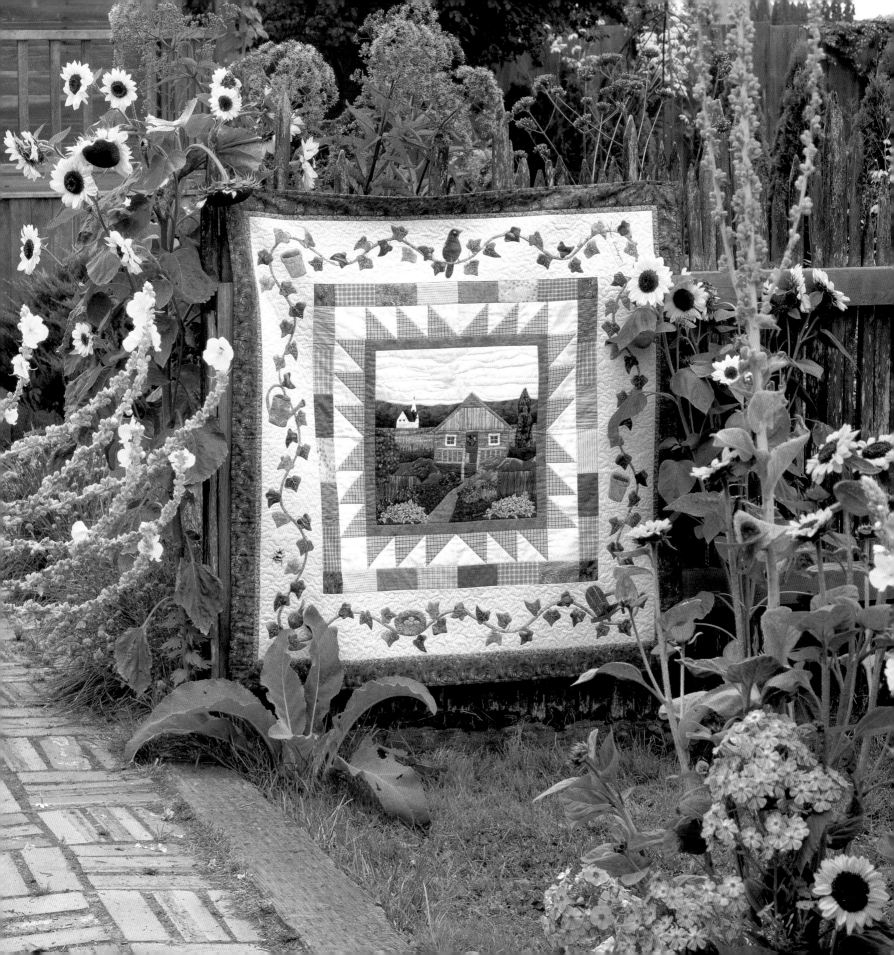

Larkspur Farm Quilt

Such a wonderful spot as Larkspur Farm deserves a wonderfully unique quilt to honor it,

and we created this beautifully appliquéd quilt to do just that. Everywhere you look,

you'll find delightful details that bring back treasured memories of the farm.

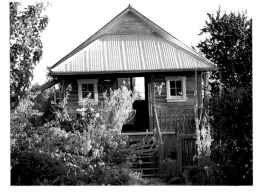

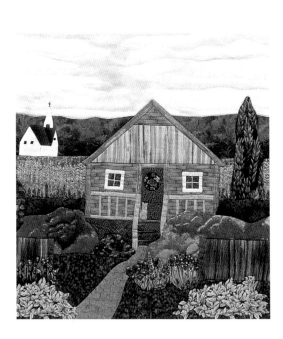

Materials

All yardage is based on 42"-wide fabric unless otherwise stated.

- ⅝ yd. blue sky fabric for appliqué background and triangle border
- ⅜ yd. green for appliqué background
- ⅜ yd. green plaid for triangle border
- Large assortment of scraps for appliqué*
- ¼ yd. brown fabric for inner border
- Assorted scraps in plaids and tone-on-tone prints for pieced border
- 1 green fat quarter for the appliquéd vine
- ⅞ yd. light tan fabric for appliqué border background (or 1 yd. if preshrunk fabric measures less than 40½" from selvage to selvage)
- ¼ yd. medium green for outer border #1
- ½ yd. dark green for outer border #2
- 3 yds. for backing
- ⅓ yd. for binding
- 51" x 51" piece of batting
- Green, black, brown, gold, and white embroidery floss
- ¼"-wide bias bar (see page 119)

*Look for fabrics that will lend a realistic look to the completed scene. For example, a tiger-print fabric makes a very realistic-looking bumblebee. Use your imagination!

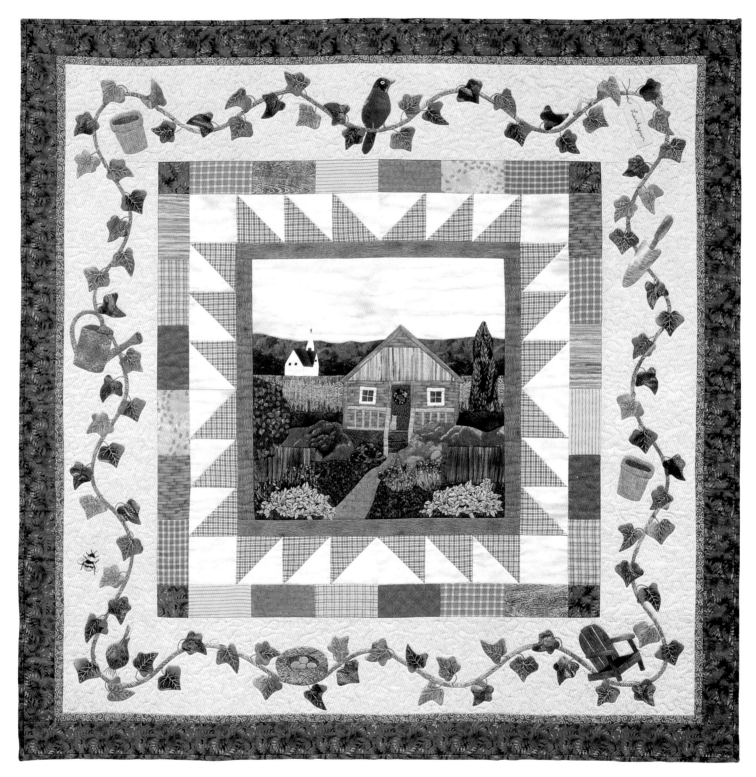

Larkspur Farm Quilt
By Jean Van Bockel, 2000, Coeur d'Alene, Idaho, 45" x 45".

Cutting

Cut all strips across the fabric width unless otherwise indicated. All measurements include ¼"-wide seam allowances.

From the blue sky fabric, cut:
- 1 rectangle, 9" x 17½", for the appliqué background
- 2 strips, each 3⅞" wide; crosscut into 12 squares, each 3⅞" x 3⅞"; cut once diagonally for a total of 24 triangles
- 4 squares, each 3½" x 3½"

From the green background fabric, cut:
- 1 rectangle, 9" x 17½"

From the green plaid, cut:
- 2 strips, each 3⅞" wide; crosscut into 12 squares, each 3⅞" x 3⅞"; cut once diagonally for a total of 24 triangles

From the brown fabric, cut:
- 2 strips, each 1½" wide; crosscut into:
 2 strips, each 1½" x 16½", for inner border
 2 strips, each 1½" x 18½", for inner border

From the assorted scraps for pieced border, cut:
- 24 rectangles, each 2½" x 4½"

From the light tan fabric, cut:
- 4 strips, each 6½" x 40½"*; crosscut 2 of these into:
 2 strips, each 6½" x 28½"

From the medium green fabric, cut:
- 5 strips, each 1" x 40½"*

From the dark green fabric, cut:
- 6 strips, each 2½" x 40½"*; set 5 strips aside and crosscut the remaining strip into 4 green squares, each 2½" x 2½", for pieced border

From the binding fabric, cut:
- 5 strips, each 2" x 40"

If the preshrunk fabric measures less than 40½", cut an extra strip and piece the strips to create borders of the required length.

Making the Center Panel

Use templates made with the patterns on pages 74–77.

1. Sew the 9" x 17½" blue sky rectangle to the 9" x 17½" green rectangle along one short edge to make a 17½" square for the appliqué background. Press the seam open.

2. Trace the appliqué templates and cut the fabric shapes from the desired fabrics (see "Needle-Turn Appliqué" on pages 117–118).

3. Position and appliqué the pieces in numerical order. Cut away the background fabric behind appliqués as you layer the pieces.

4. Trim the completed center panel to 16½" x 16½", taking care to center the work in the square.

Adding the Inner Border

1. Sew a 1½" x 16½" brown border strip to opposite sides of the panel. Press the seams toward the border strips. Add the 1½" x 18½" strips to the top and bottom edges. Press.

2. Make 24 pieced squares using the blue sky and green plaid triangles. Press the seams toward the green triangle in each unit.

Make 24.

3. Arrange the pieced squares into 4 identical strips of 6 units each, with the green triangles reversing direction from the center out in each strip. Press the seams toward the green triangles. Add a 3½" blue sky square to each end of 2 of these strips. Press the seams toward the squares.

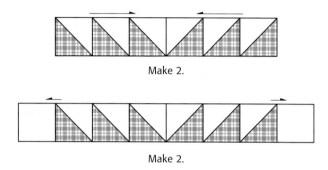

Make 2.

Make 2.

4. Sew the shorter triangle border strips to opposite edges of the appliqué panel, with the long edges of the green triangles next to the brown border (see quilt plan on page 73). Press the seams toward the brown border strips. Repeat with the remaining triangle borders.

5. Assemble 4 pieced rectangle borders with 6 scrap 2½" x 4½" rectangles in each one. Press the seams to one side in each unit. Add 2½" dark green squares to opposite ends of 2 of these borders. Press toward the squares.

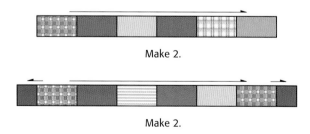

Make 2.

Make 2.

6. Add the shorter pieced rectangle borders to opposite sides of the center panel; press the seams toward the rectangle borders. Add the remaining rectangle borders to the top and bottom edges of the quilt top. Press.

7. Sew a 6½" x 28½" light tan strip to opposite sides of the quilt top. Press seams toward the light tan strips. Add the 6½" x 40½" light tan strips to the remaining edges. Press.

Adding the Appliqués

1. Cut enough 1"-wide bias strips from the green fat quarter to make a 195"-long strip. Sew the strips together and prepare a vine, using the ¼"-wide bias bar (see "Appliqué Vines" on page 119).

2. Referring to the quilt photo for vine placement, baste the vine in place. Create gentle curves and keep the vine at least 2" from the outer edge of the border strips. Sew in place with the appliqué stitch (see page 119).

3. Prepare 84 ivy leaves, using the 3 ivy leaf patterns on page 79. Add variety to your selection of shapes by tracing half the leaves in reverse. If your fabric does not have printed "veins," you can embroider them with a stem stitch, referring to the veins on the leaf patterns.

4. Prepare garden objects for appliqué (see pages 78–79). Baste in place, adding pieces in numerical order. Refer to the quilt photo for positioning. Add ivy leaves along the vine and baste in place. Appliqué.

5. Embroider leaf stems using the stem stitch and 3 strands of green floss. Use a satin stitch with 2 strands of gold floss for the robin's beak and feet. Use a white stem stitch for the robin's eye and add a black French knot to finish. Use 2 strands of floss for each eye color.

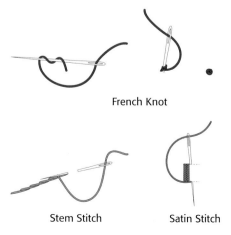

French Knot

Stem Stitch Satin Stitch

6. Use 1 strand of black floss in a satin stitch for the 2 church windows, and add a cross to the steeple. Use a stem stitch for all other details, using 1 strand of floss in the appropriate color for each one.

Adding the Outer Border

1. Sew 1" x 40½" medium green outer border strips to opposite sides of the quilt top. Press the seams toward the borders. Use the remaining border strips to make two border strips, each 1" x 41½". Sew to the top and bottom edges of the quilt top. Press.

2. Add the 2½" x 41½" dark green outer border strips to opposite sides of the quilt top and press toward the outer borders. Use the remaining dark green strips to make 2 border strips, each 2½" x 45½". Add the border strips to the top and bottom edges of the quilt top.

Finishing Your Quilt

Refer to the "General Directions," beginning on page 117, for specific directions in each of the following finishing steps.

1. Layer the quilt top with batting and backing; baste.

2. Hand or machine quilt as desired.

3. Trim the backing and batting even with the quilt-top edges.

4. Sew the 2"-wide binding strips together and bind the quilt.

Quilt Plan

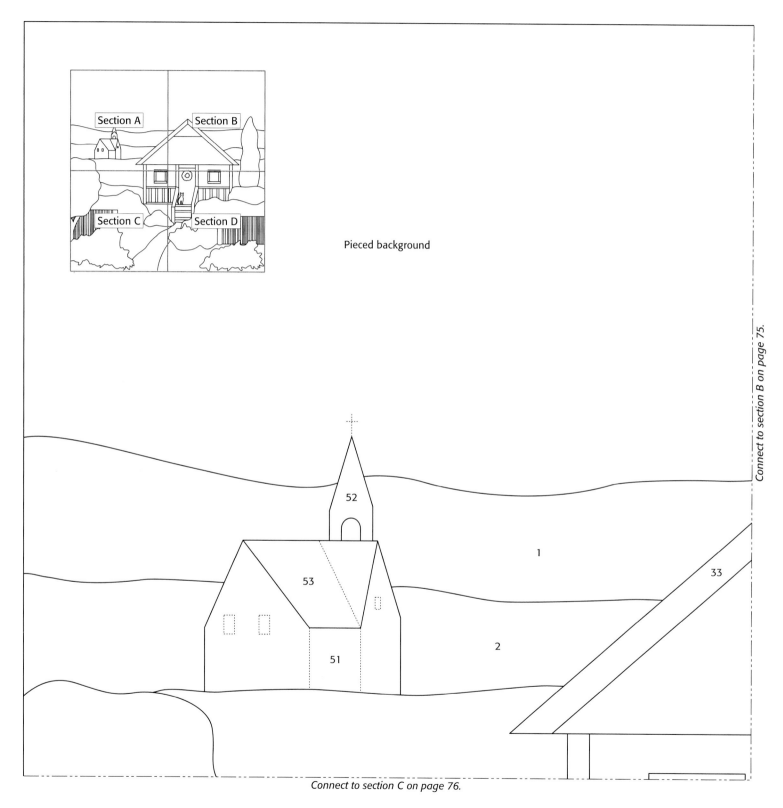

Section A

Pieced background

Connect to section B on page 75.

52

53

51

1

33

2

Connect to section C on page 76.

Section A
Refer to section piecing diagram above.

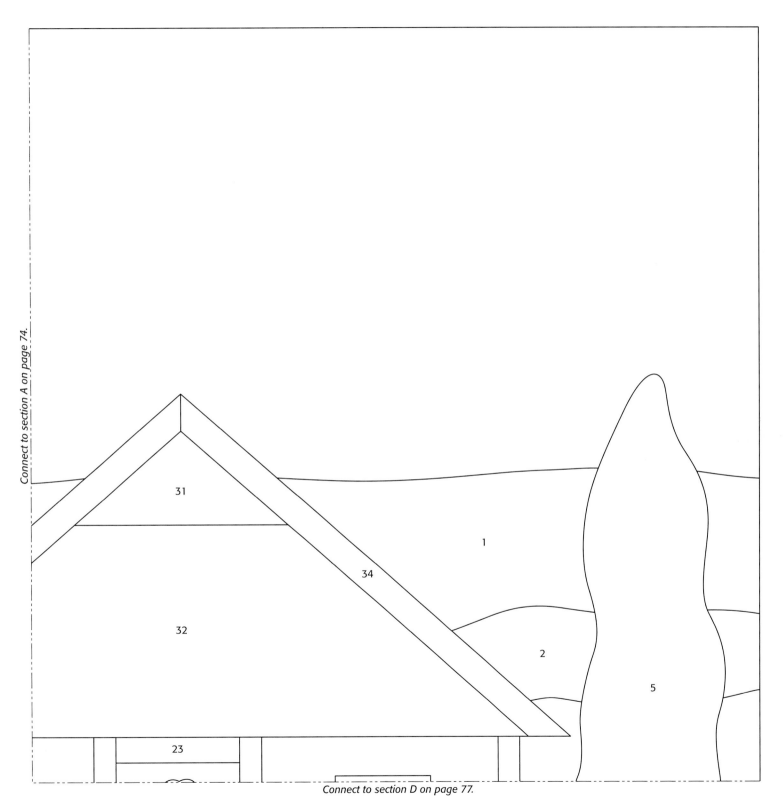

Connect to section A on page 74.

Connect to section D on page 77.

Section B
Refer to section piecing diagram on page 74.

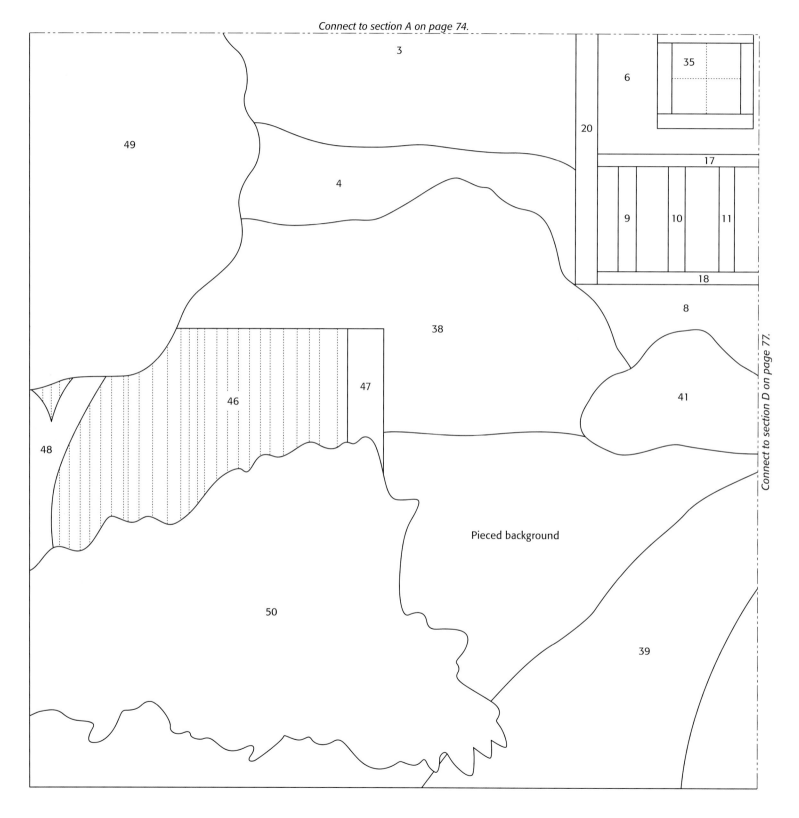

Connect to section A on page 74.

Connect to section D on page 77.

Pieced background

Section C
Refer to section piecing diagram on page 74.

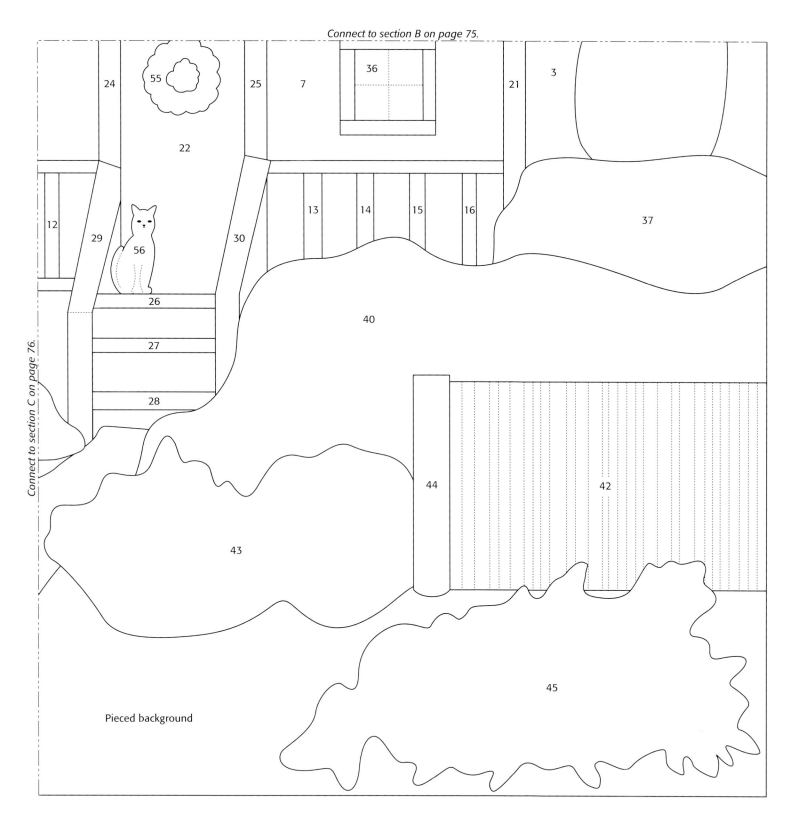

Connect to section B on page 75.

Connect to section C on page 76.

24

55

25

7

36

21

3

22

12

29

56

30

13

14

15

16

37

26

40

27

28

44

42

43

45

Pieced background

Section D
Refer to section piecing diagram on page 74.

Appliqué Patterns

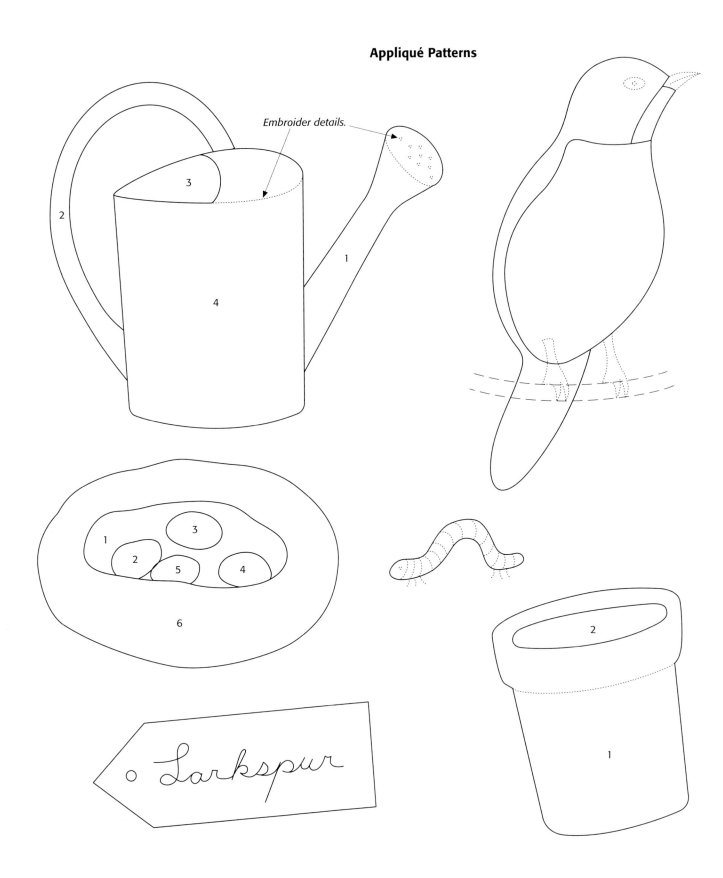

Embroider details.

Larkspur

Appliqué Patterns

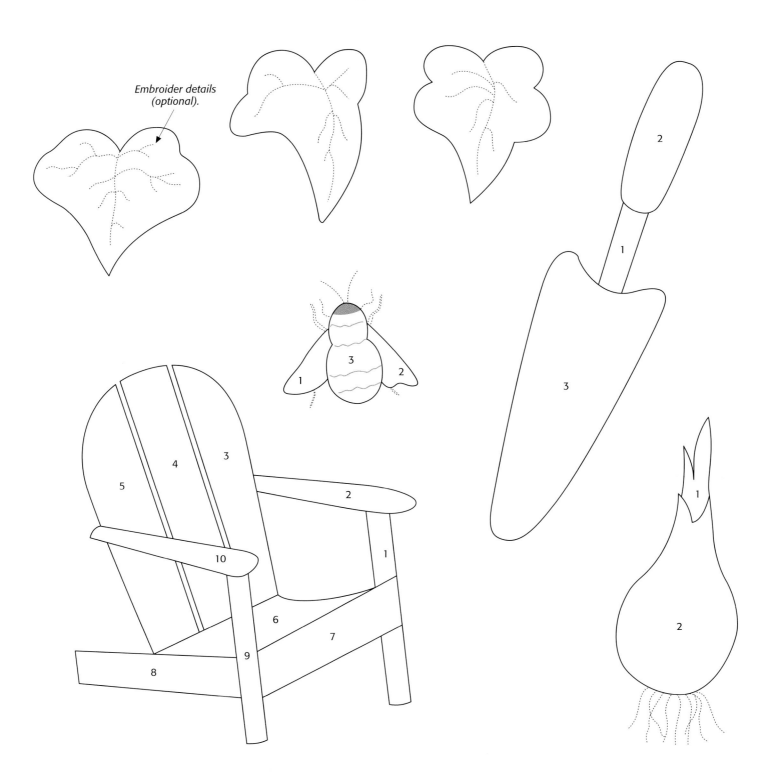

Embroider details (optional).

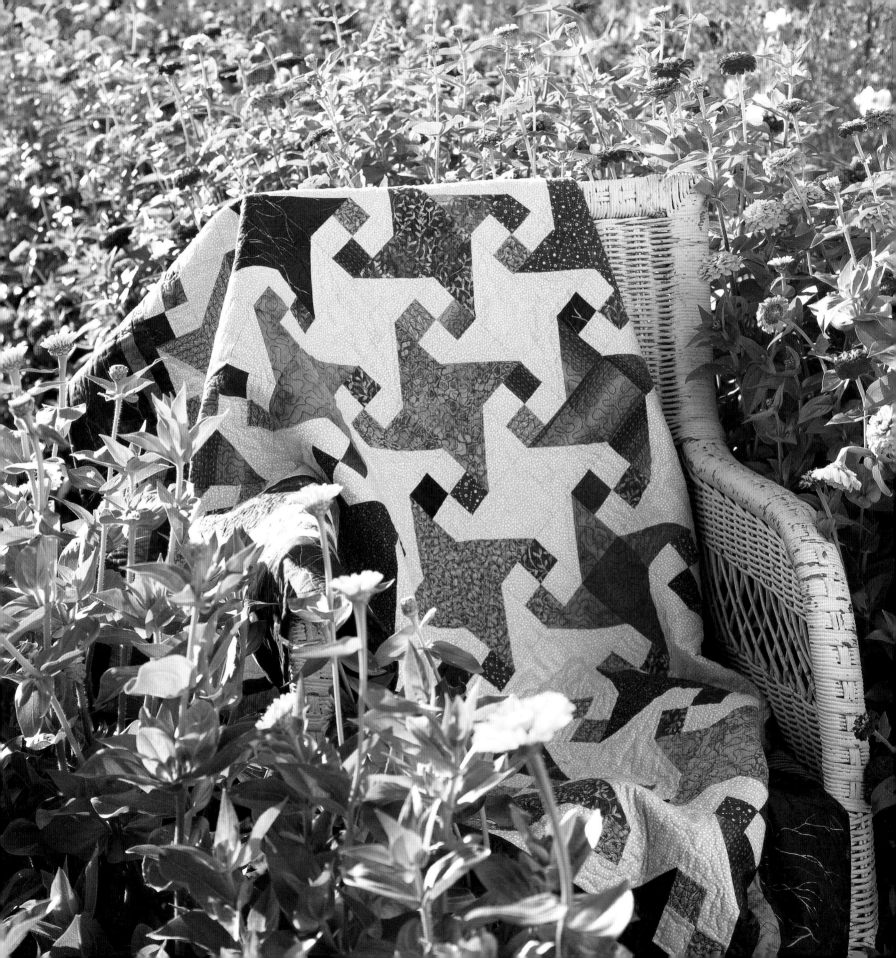

Zinnia Patch

When the shadows of summer grow just a little longer, brilliant zinnias make their annual appearance

at Larkspur Farm. This eye-catching quilt, made with the same blocks as the two-color "Blaze"

on page 63, is bathed in rich shades of rose, peach, gold, and orange—

just like a patch of late-summer zinnias.

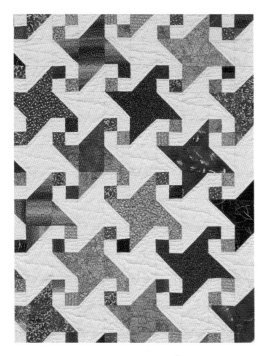

Materials

All yardage is based on 42"-wide fabric unless otherwise stated.

- 1⅓ yds. yellow print for blocks
- 1⅜ yds. assorted red and orange prints (or 3½" strips of assorted colors)
- ⅜ yd. dark green print for inner border
- ⅜ yd. bright pink print for middle border
- 1¼ yds. deep red print for outer border
- 3½ yds. for backing
- ⅔ yd. for binding
- 58" x 70" piece of batting

Tip

The more fabrics in this quilt the better! Use as many lovely zinnia colors as you can find in your scrappy assortment! To include more fabrics, cut shorter 3½"-wide or 3⅞"-wide strips. Instead of 8 strips, each 40" long, cut 16 strips, each 20" long, or even 24 strips that are 14" long. If you have a few extra pieces, you will have more to choose from as you lay out the pieces for your quilt top.

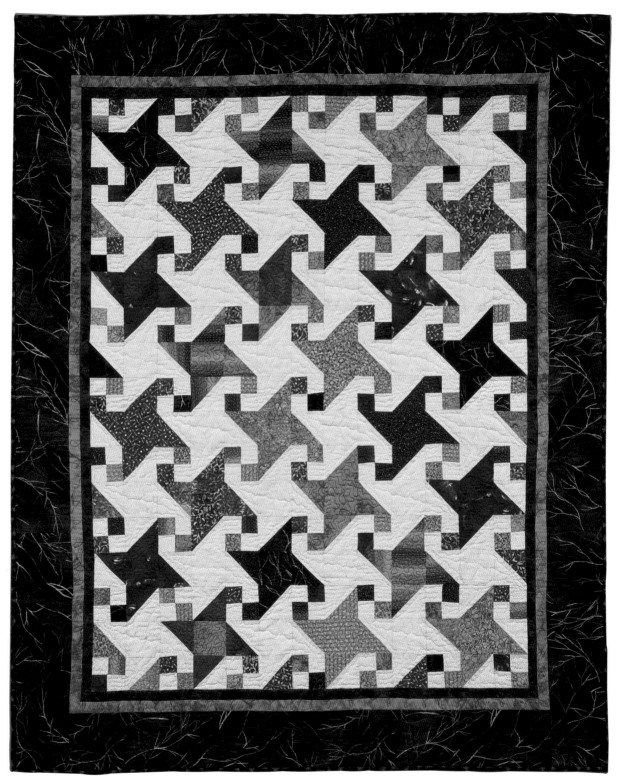

Zinnia Patch
By Pamela Mostek, 2000, Cheney, Washington, 53" x 65".

Cutting

Cut all strips across the fabric width. All measurements include ¼"-wide seam allowances.

From the yellow print, cut:
- 4 strips, each 2" wide
- 3 strips, each 3½" wide; crosscut into 24 squares, each 3½" x 3½"
- 6 strips, each 3⅞" wide; crosscut into 55 squares, each 3⅞" x 3⅞"; cut once diagonally for a total of 110 triangles

From the red and orange prints, cut:
- 4 strips, each 2" wide
- 3 strips, each 3½" wide; crosscut into 24 squares, each 3½" x 3½"
- 6 strips, each 3⅞" wide; crosscut into 55 squares, each 3⅞" x 3⅞"; cut once diagonally for a total of 110 triangles

From the dark green print, cut:
- 5 strips, each 1½" wide, for inner border

From the bright pink print, cut:
- 5 strips, each 1½" wide, for middle border

From the deep red print, cut:
- 7 strips, each 5½" wide, for outer border

From the binding fabric, cut:
- 7 strips, each 2¾" wide

Making the Blocks

1. Referring to the directions for the Four Patch blocks on page 65, make 63 blocks. Use the 4 yellow strips, each 2" wide, and the 4 assorted red and orange strips, each 2" wide.

2. Referring to the directions for the half-square triangle blocks on page 65, use 110 yellow triangles and 110 assorted red and orange triangles to make 110 half-square triangle blocks. Make at least 24 matching sets of 4 (96). The remainder of the blocks may be assorted colors.

Make 63. Make 110.

Assembling the Rows and Adding the Borders

1. Using the Four Patch and half-square triangle blocks, the remaining 3½" yellow squares, and the remaining assorted red and orange 3½" squares, assemble rows 1, 2, 3, and 4 as shown to make section 1. Sew rows together in numerical order.

2. Repeat step 1 to make sections 2, 3, and 4.

Section 1
Repeat for sections 2, 3, and 4.

3. Sew sections 1–4 together. Make an additional row 1 and add to the bottom edge of the quilt top. Press the seams in one direction.

4. Cut 1 dark green inner-border strip in half and sew a half strip to each of 2 dark green 1½" x 40" inner border strips. Measure, trim, and sew to the quilt as directed in "Adding Borders" on pages 120–121. Prepare and add the middle borders in the same manner, followed by the outer borders.

Finishing Your Quilt

Refer to the "General Directions," beginning on page 117, for specific directions in each of the following finishing steps.

1. Layer the quilt top with batting and backing; baste.

2. Machine or hand quilt as desired.

3. Trim the batting and backing even with the quilt-top edges.

4. Sew the 2¾"-wide binding strips together into one long strip and bind the quilt.

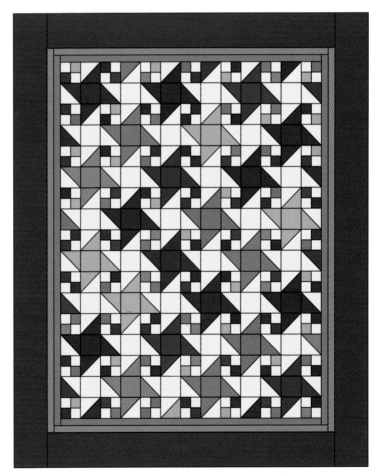

Quilt Plan

Garden Art

*I*F IT'S UNIQUE, a delight to the eyes, and nestled into a lovely garden spot—it's garden art! Larkspur Farm is the home of a wide variety of garden art pieces—from highly prized metal sculptures to a vintage playground slide—and each one adds a bit of charm and character to the natural beauty of the surroundings.

Smaller pieces, which are easier to find and display, are a great way to start adding art to your garden. First, check out your local garden shop. They may have small stone balls or shallow, bowl-shaped vessels to hold water. Or take an afternoon to visit antique shops. Look for unique items and things that you might not otherwise give a second thought—an aged and rusting metal gate can add an artful touch to a blooming corner, for example. Let your imagination go as you wander through the shops searching for just the right treasures for your garden decor. Only one thing really matters when collecting art of any kind—*you* have to love it!

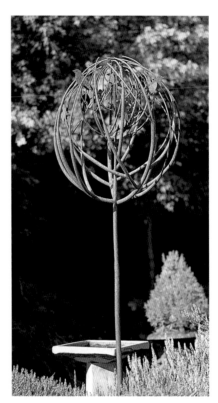

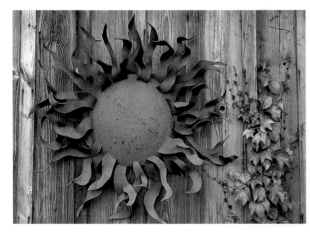

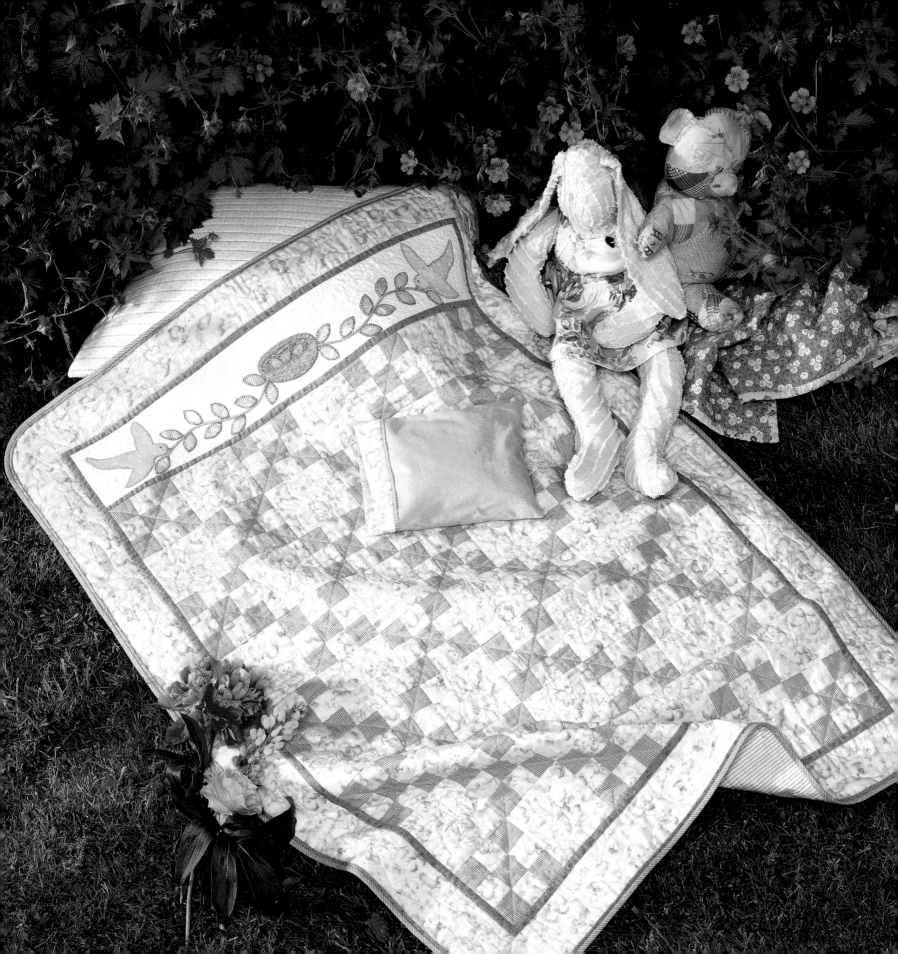

Nesting

Snugly nestled into a bed of trailing vines and blooms, baby can spend the afternoon dreaming of sweet-smelling flowers and singing birds overhead. Tucked under this sweet quilt amid the garden delights, baby will surely have a heavenly nap.

Materials

All yardage is based on 42"-wide fabric unless otherwise stated.

- 2 yds. floral print for blocks and outer border
- 1¼ yds. light green stripe for Nine Patch blocks and bias binding
- ¼ yd. white for appliqué panel
- Yellow scrap for birds
- Pink scrap for birds' breasts
- Gold scrap for birds' beaks
- Tan scrap for nest
- Blue scrap for eggs
- Green scraps for vine and leaves
- ¼ yd. pink for inner border
- 1 pink fat quarter for bias trim
- 1⅔ yds. for backing (must be at least 44" wide after preshrinking, or buy 2 lengths)
- *Optional:* ⅓ yd. fusible web for fusible appliqué
- Brown, green, and blue embroidery floss
- ¼"-wide bias bar (see page 119)
- 46" x 60" piece for batting

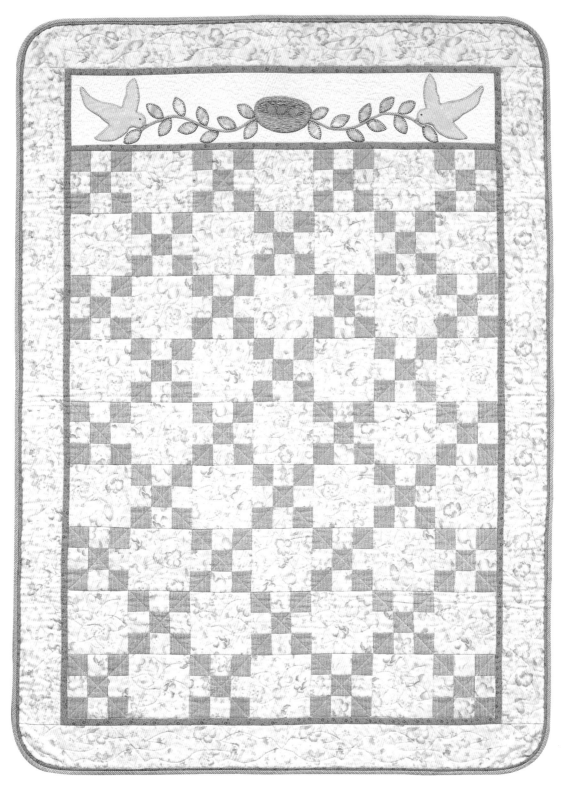

Nesting
By Jean Van Bockel, 2000, Coeur d'Alene, Idaho, 40" x 54".

Cutting

Cut all strips across the fabric width. All measurements include ¼"-wide seam allowances.

From the floral print, cut:
- 5 strips, each 5" wide; crosscut into 31 squares, each 5" x 5", for blocks
- 8 strips, each 2" wide, for blocks
- 6 strips, each 4" wide, for outer border

From the light green stripe fabric, cut:
- 10 strips, each 2" wide, for blocks
- Enough 2"-wide bias strips to make a 200"-long piece for binding.

From the white fabric, cut:
- 1 strip, 5½" x 32", for appliqué background

From the pink inner border fabric, cut:
- 3 strips, each 1" x 32"
- 3 strips, each 1" wide

NOTE: See "Finishing Your Quilt" on page 91 for cutting the pink trim.

Making the Nine Patch Blocks

1. Sew 2"-wide light green and floral strips together as shown to make 4 of strip set A and 2 of strip set B for the blocks. Press the seam allowances toward the green strips in each set. Cut a total of 64 segments, each 2" wide, from the A strip sets. Cut 32 segments, each 2" wide, from the B strip sets.

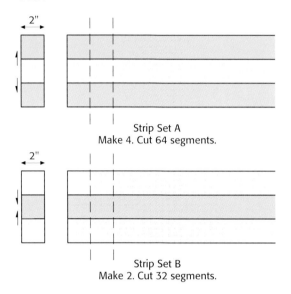

Strip Set A
Make 4. Cut 64 segments.

Strip Set B
Make 2. Cut 32 segments.

2. Arrange the segments into 32 Nine Patch blocks and sew the segments together. Press.

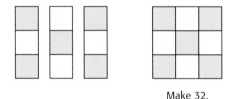

Make 32.

3. Alternating the Nine Patch blocks with the 5" floral squares, sew together the pieces to make 5 row A. Begin and end with a Nine Patch block. Make 4 row B, beginning and ending with a floral square. Press all seams toward the floral squares.

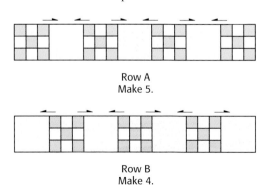

Row A
Make 5.

Row B
Make 4.

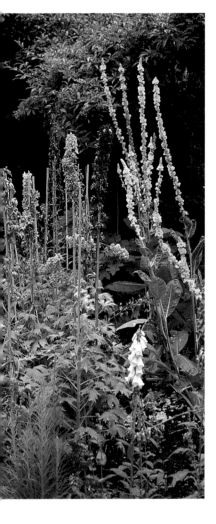

4. Beginning and ending with row A, sew rows together in alternating fashion to complete the Irish Chain quilt center (refer to quilt plan on page 92). Press seams in one direction.

Adding the Appliqués

Use templates made with the patterns on page 93.

1. Trace the pattern shapes as directed for freezer-paper or needle-turn appliqué on pages 117–118. Cut the required number of shapes from each of the appropriate fabrics, adding $\frac{1}{16}$" allowances all around each one. (If you prefer the fusible appliqué method, adjust the template preparation, following the directions on pages 118–119.) For the vines, cut and prepare 2 bias strips, each 1" x 10", from a scrap of green fabric (see "Appliqué Vines" on page 119).

2. Fold the 5½" x 32" white strip in half crosswise and finger-press to mark the center for a positioning guide. Center the nest over the crease with the top edge of the nest 2" from the top edge of the panel. Pin or baste in place. Position birds with their tails approximately 1" from the short end of the panel, and the lower wings ½" from the lower edge of the panel. Position each vine, tucking one end of vine under the edge of the nest and winding it gently to

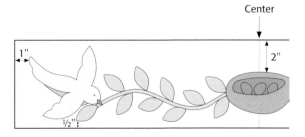

the bird's beak. Position 10 leaves along each vine. Appliqué the vines first, then sew (or fuse) the remaining pieces in place in numerical order.

3. Embellish the nest and birds with buttonhole stitching, using 3 strands of brown embroidery floss. Add green buttonhole stitching around each leaf, and blue around the eggs. Make the birds' eyes with French knots, using 6 strands of blue floss.

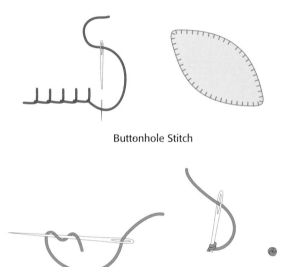

Buttonhole Stitch

French Knot

Assembling the Quilt Top

1. Sew a 1" x 32" pink inner border strip to the top and the bottom edges of the appliqué panel and to the lower edge of the pieced panel. Press the seams toward the pink strips. Sew the appliqué panel to the top edge of the pieced panel.

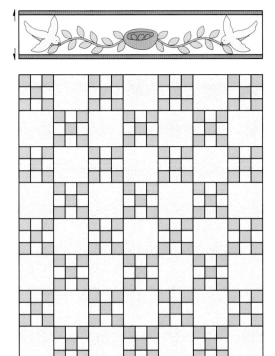

2. Cut a 1"-wide pink strip in half and sew a half strip to each of the remaining inner border strips. Measure the length of the quilt top through the center and trim the strips to match (approx. 47½"). Add to the sides of the quilt top. Press toward the border strips.

3. Cut and piece 2 floral 4"-wide border strips to match the measurement in step 2 (approx. 47½"). Sew to the long edges of the quilt top. Press the seams toward the borders.

4. Measure the width of the quilt top through the center and piece 2 floral borders to match this measurement (approx. 40"). Sew to the top and bottom edges of the quilt top. Press.

Finishing Your Quilt

Refer to the "General Directions," beginning on page 117, for specific directions in each of the following finishing steps.

1. Layer the quilt top with batting and backing; baste.

2. Machine or hand quilt as desired.

3. Trim the batting and backing even with the quilt-top edges.

4. For rounded corners, place a bowl or saucer on each corner and trace around the edge with a pencil. Cut on the pencil lines.

5. For the bias trim, cut the pink fat quarter into 1"-wide bias strips (see "Bias Binding" on page 124). Sew the strips together into one long strip, approximately 200" long. Fold the strip in half lengthwise with wrong sides together and press. With raw edges even and using a scant ¼"-wide seam, baste the bias strip to the quilt-top outer edge, easing it rather than stretching it to fit around the corners. After binding the outer edge, the folded edge of the pink trim will lie against the surface of the quilt, just as you have basted it.

6. Sew the 2"-wide light green-stripe bias strips together to make a 200"-long piece of binding and bind the quilt.

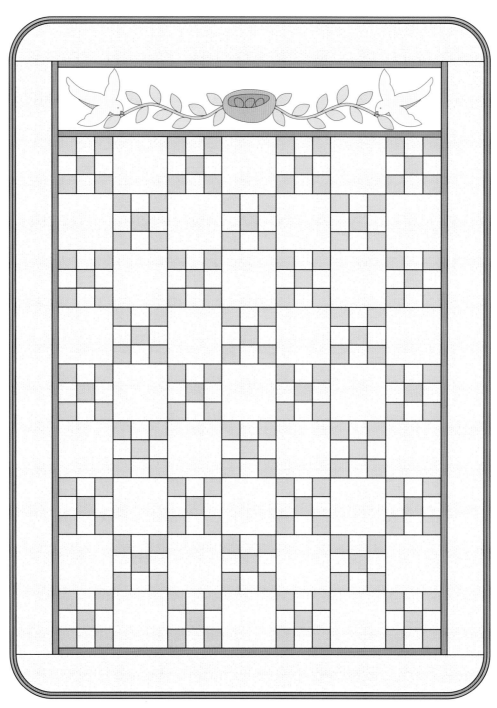

Quilt Plan

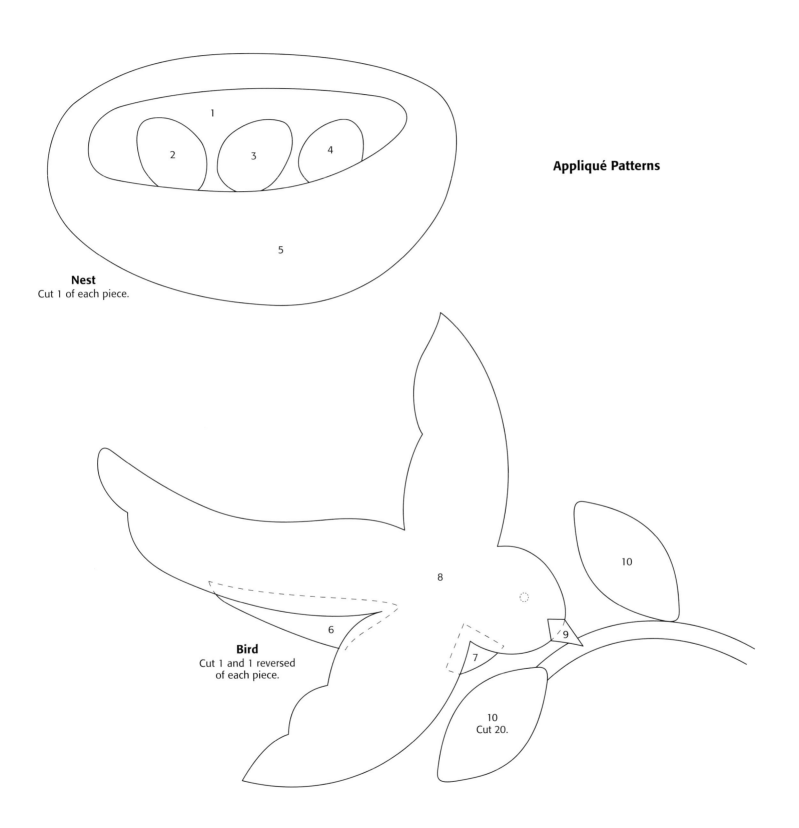

Appliqué Patterns

Nest
Cut 1 of each piece.

Bird
Cut 1 and 1 reversed
of each piece.

10
Cut 20.

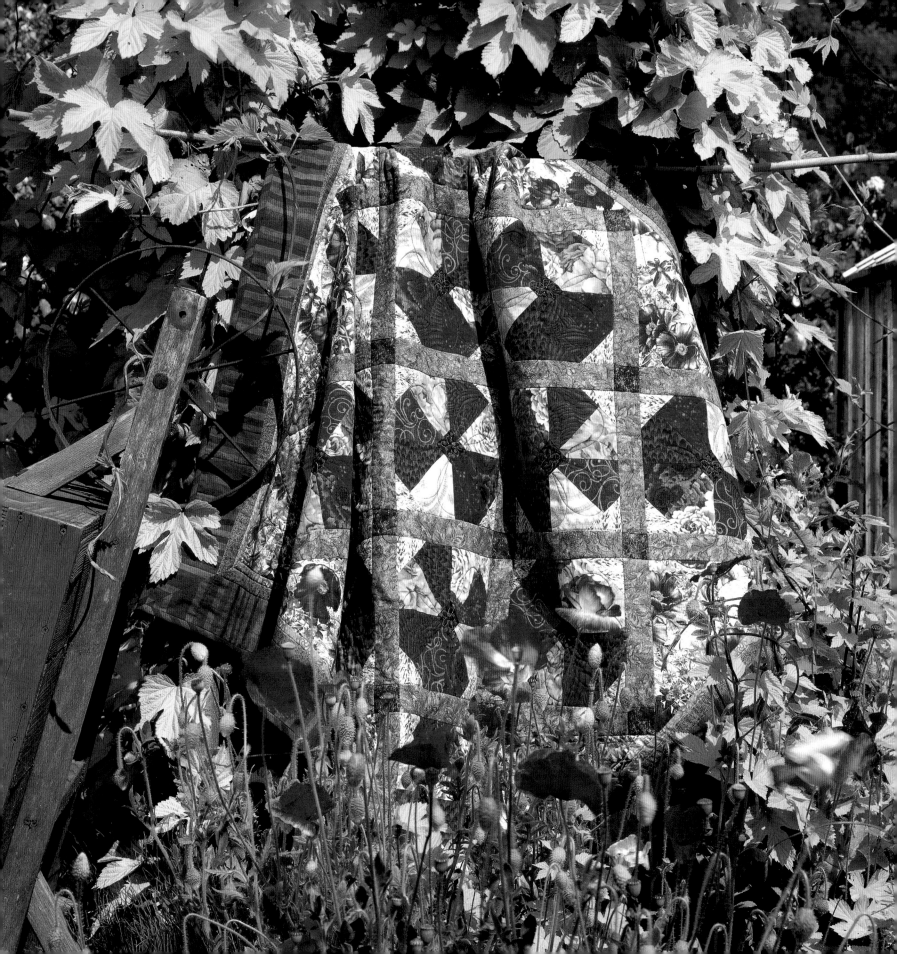

Poppy Fields

Blazing with bold shades of red and pink, the poppies burst into bloom in early spring.

Just one of the array of beautiful flowers that share the spotlight at Larkspur Farm,

poppies inspired the vivid colors in this stunning quilt.

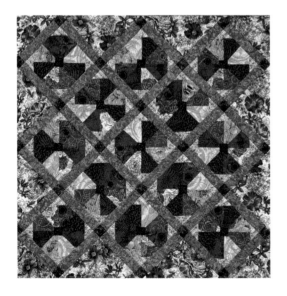

- ⅛ yd. black print for poppy centers
- ⅜ yd. light print for poppy block corners
- ¾ yd. floral print for setting triangles
- ⅝ yd. green for sashing
- ⅙ yd. purple print for sashing squares
- ¼ yd. green for inner border
- ¼ yd. purple for middle border
- ⅔ yd. striped fabric for outer border
- 3¼ yds. for backing
- ⅜ yd. for binding
- *Optional:* Fabric scraps and black embroidery floss for appliquéd bumblebee
- 57" x 57" piece of batting

Materials

All yardage is based on 42"-wide fabric unless otherwise stated.

- ¼ yd. each of 8 pink to dark red prints for poppies

Cutting

Cut all strips across the fabric width. All measurements include ¼"-wide seam allowances.

From *each* of the 8 pink to dark red fabrics, cut:

- 1 strip, 4⅞" wide; crosscut into: 7 squares, each 4⅞" x 4⅞"; cut once diagonally for 14 triangles from each strip (112 total)

From the black print, cut:

- 2 strips, each 1½" wide; crosscut into 52 squares, each 1½" x 1½"

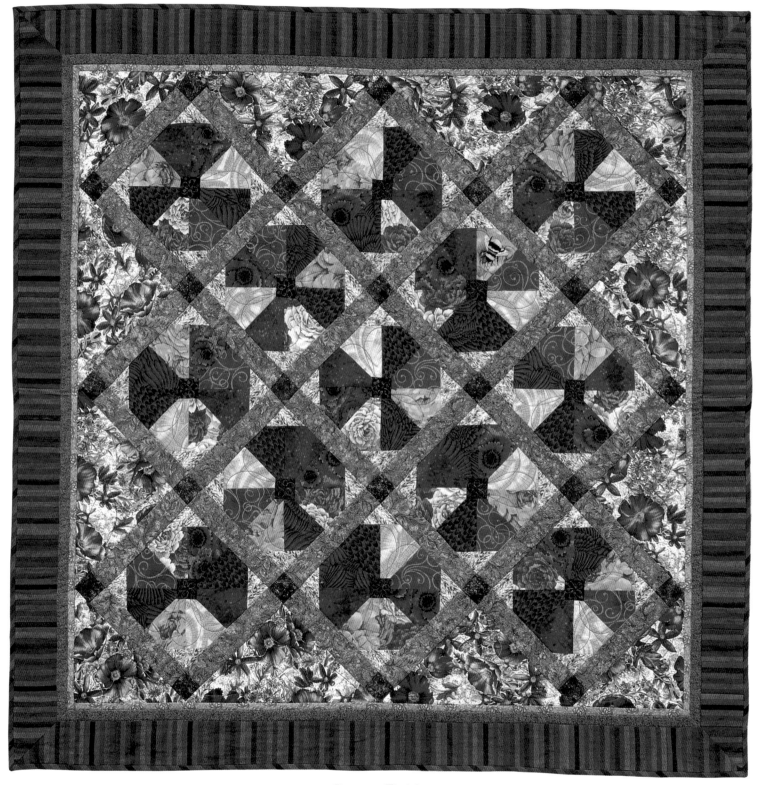

Poppy Fields
By Jean Van Bockel, 2000, Coeur d'Alene, Idaho, 51½" x 51½".

From the light print, cut:
- 4 strips, each 2½" wide; crosscut into 52 squares, each 2½" x 2½"

From the floral print, cut:
- 2 squares, each 15" x 15"; cut twice diagonally for a total of 8 side setting triangles
- 2 squares, each 8⅝" x 8⅝"; cut once diagonally for a total of 4 corner setting triangles

From the green sashing fabric, cut:
- 9 strips, each 2" wide; crosscut into 36 strips, each 2" x 8½"

From the purple print, cut:
- 2 strips, each 2" wide; crosscut into 24 squares, each 2" x 2", for sashing squares

From the green inner border fabric, cut:
- 6 strips, each 1" wide

From the purple middle border fabric, cut:
- 6 strips, each 1¼" wide

From the striped outer border fabric, cut:
- 6 strips, each 3½" wide

From the binding fabric, cut:
- Enough 2½"-wide bias strips to make a 214"-long piece.

Making the Blocks

1. Choose eight 4⅞" pink to dark red triangles at random and sew into pairs along the diagonal edges. Press the seam toward one triangle in each pair.

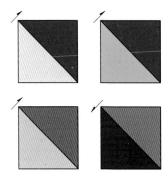

Make 4 different triangle squares.

2. On the wrong side of 4 light 2½" squares, lightly draw a diagonal pencil line from corner to corner. Repeat on the wrong side of 4 black 1½" squares, using a white or yellow marking pencil.

3. Position a marked light square, right side down, on the upper left corner of each of the pieced squares from step 1. Stitch on the line and cut away the corner ¼" from the stitching. Press the seam toward the light triangle.

 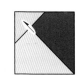

Make 4.

Add a black square to the lower right corner in the same manner. Make 4.

Make 4.

4. Sew the units from step 3 together in pairs and press the seam allowances in opposite directions. Sew the units together to complete 1 Poppy block.

5. Repeat steps 1–4 to make a total of 13 Poppy blocks.

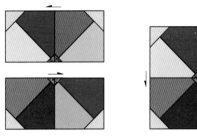

Make 13.

Assembling the Quilt Top

1. Sew a 2" x 8½" green sashing strip to one side of 8 Poppy blocks (unit A). Sew 2 green sashing strips to opposite sides of the remaining 5 blocks (unit B). Press the seams toward the sashing.

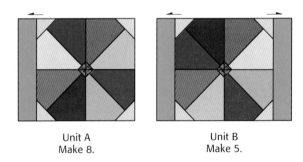

Unit A
Make 8.

Unit B
Make 5.

2. Arrange the sashed blocks in diagonal rows, following the layout above right. Join the rows and press the seams toward the sashing in each row.

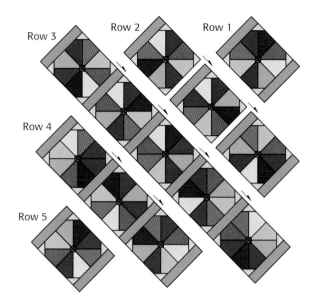

Row 3 Row 2 Row 1

Row 4

Row 5

3. Sew the remaining 2" x 8½" green sashing strips and 2" purple sashing squares together to make the sashing units shown. Press the seams toward the sashing.

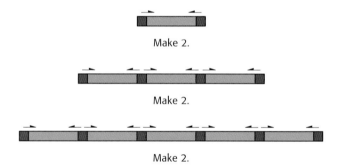

Make 2.

Make 2.

Make 2.

4. Sew the sashing units to the Poppy block rows and press the seams toward the sashing. Add the large floral side setting triangles to the row ends and press the seams toward the setting triangles. Sew the rows together and press the seams toward the sashing.

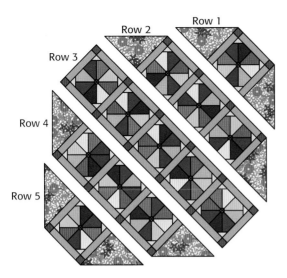

5. Add the 4 floral corner setting triangles and press the seams toward the triangles.

Optional Appliqué

1. For hand appliqué (see "Needle-Turn Appliqué" on pages 117–118), trace pattern shapes for bumblebee. Cut shape from the desired fabrics, adding a $\frac{1}{16}$"-wide seam allowance around the entire shape. (If you prefer, substitute the "Fusible Appliqué" method on pages 118–119.)

2. Position the bumblebee on one of the poppies and hand appliqué or fuse it in place. Use a stem stitch with 1 strand of black embroidery floss for the narrow leg sections and the antennae. Use a satin stitch for the wider leg sections.

Appliqué Pattern

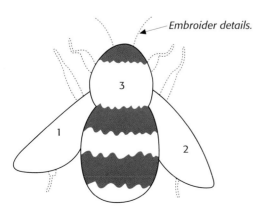

Embroider details.

Adding the Borders

1. Sew the green inner border strips together to make 4 inner border strips, each 54" long. Repeat with the purple middle border strips and the striped outer border strips.

2. Sew the inner, middle, and outer border strips together in 4 sets.

3. Sew the borders to the quilt top, following the directions for "Mitered Borders" on pages 120–121.

Finishing Your Quilt

Refer to the "General Directions," beginning on page 117, for specific directions in each of the following finishing steps.

1. Layer the quilt top with batting and backing; baste.

2. Machine or hand quilt as desired.

3. Trim the batting and backing even with the quilt-top edges.

4. Sew the 2½"-wide bias binding strips together into one long strip and bind the quilt.

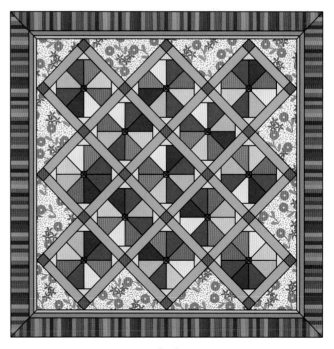

Quilt Plan

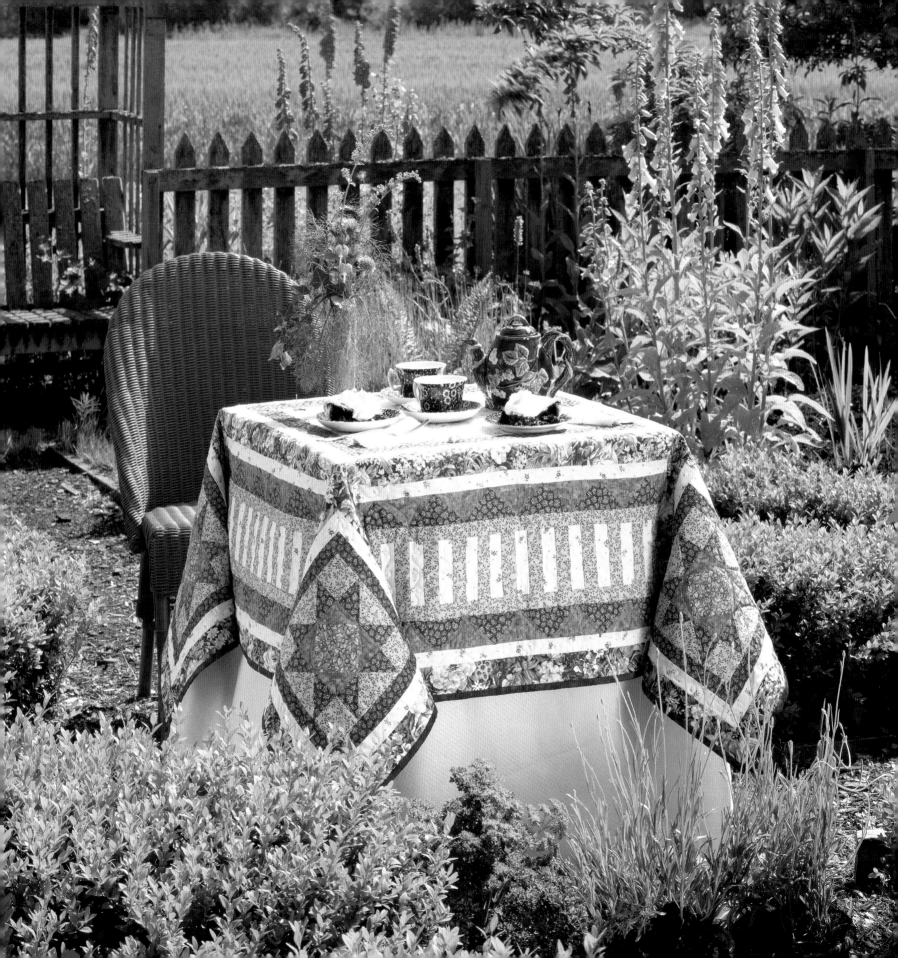

Tea in the Garden

A perfect spot for tea! Surrounded by vine-covered arbors and the sweet fragrance of lavender,

this formal herb garden is a delightful setting for tea— with this unique,

multibordered quilt as the perfect backdrop.

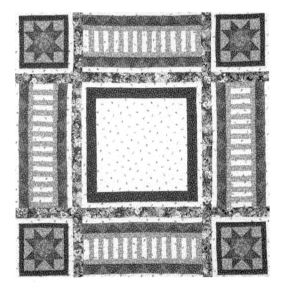

Materials

All yardage is based on 42"-wide fabric unless otherwise stated.

- 1 yd. green print for corner squares and "striped" border
- 1¾ yds. light print for center square, striped borders, and narrow borders
- ⅔ yd. blue print for triangle border and corner squares
- ⅔ yd. rose print for triangle border and corner squares
- ¼ yd. green-and-rose print for corner-square centers
- ¾ yd. burgundy print for center-square and corner-square borders
- 1⅛ yds. large-scale floral print for sashing and outer border
- 3½ yds. for backing
- ⅝ yd. for binding
- 62" x 62" piece of batting

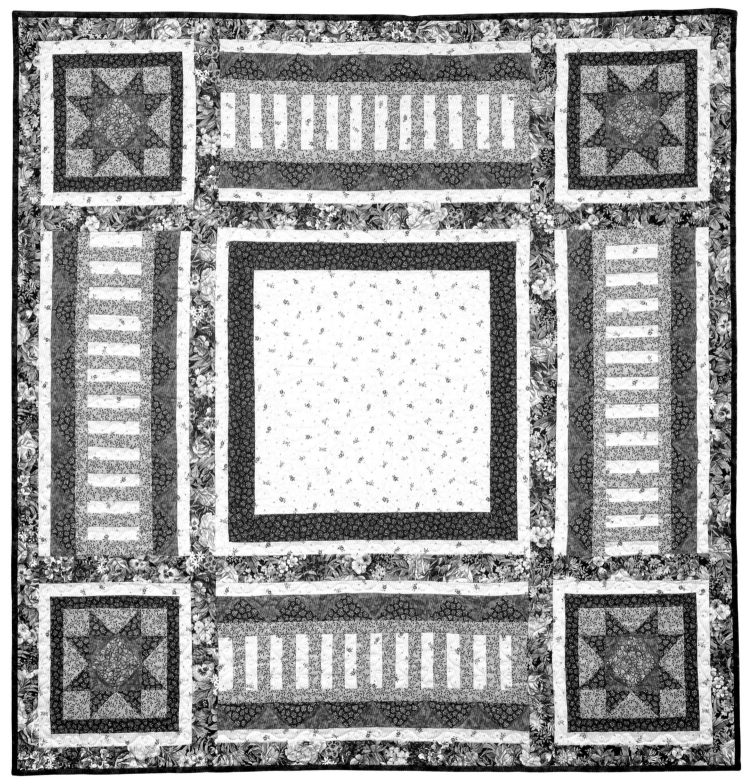

Tea in the Garden
By Pamela Mostek, 2000, Cheney, Washington, 56" x 56".

Cutting

Cut all strips across the fabric width. All measurements include ¼"-wide seam allowances.

From the green print, cut:
- 14 strips, each 1½" wide
- 3 strips, each 2½" wide; crosscut into:
 - 16 rectangles, each 2½" x 4½"
 - 16 squares, each 2½" x 2½"

From the light print, cut:
- 1 square, 18½" x 18½"
- 21 strips, each 1½" wide; set 6 strips aside and crosscut the remaining strips into the required pieces in the order below:
 - From *each* of 8 strips, cut 1 strip, 1½" x 24½", and 1 strip, 1½" x 12½"
 - From 3 of the remaining strips, cut a total of 8 strips, each 1½" x 10½"
 - From the remaining 4 strips, cut a total of 2 strips, each 1½" x 22½", and 2 strips, each 1½" x 24½"

From the blue print, cut:
- 8 strips, each 2½" wide, crosscut into:
 - 48 rectangles, each 2½" x 4½"
 - 32 squares, each 2½" x 2½"

From the rose fabric, cut:
- 7 strips, each 2½" wide; crosscut into 112 squares, each 2½" x 2½"

From the green-and-rose print, cut:
- 1 strip, 4½" wide; crosscut into 4 squares, each 4½" x 4½"

From the burgundy print, cut:
- 5 strips, each 1½" wide; crosscut into:
 - 8 strips, each 1½" x 8½"
 - 8 strips, each 1½" x 10½"
- 3 strips, each 2½" wide; crosscut into:
 - 2 strips, each 2½" x 18½"
 - 2 strips, each 2½" x 22½"

From the large-scale floral print, cut:
- 13 strips, each 2½" wide; set 6 strips aside and crosscut 7 strips into:
 - 8 strips, each 2½" x 12½"
 - 4 strips, each 2½" x 24½"

From the binding fabric, cut:
- 6 strips, each 2¾" wide

Making the Center Panel

1. Sew a 2½" x 18½" burgundy strip to the top and bottom edges of the 18½" light print square. Press the seams toward the burgundy strips. Sew the 22½"-long burgundy strips to the remaining sides. Press.

2. Add the 1½" x 22½" light print strips to the top and bottom edges of the panel, then add 1½" x 24½" light print strips to the sides. Press the seams toward the burgundy strips. Set the panel aside.

Making the Borders

1. Beginning with a green strip, sew 3 green 1½"-wide strips and 3 light print 1½"-wide strips together. Press the seams toward the green strips. Repeat to make a second strip set like the first. Cut each strip unit into 4½"-wide segments for a total of 16 segments.

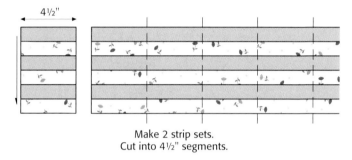

4½"

Make 2 strip sets.
Cut into 4½" segments.

2. Make 4 striped border units, each containing 4 segments from step 1. They should each measure 24½". Trim the 8 remaining green border strips to 24½". Add a green strip to each long edge of the striped border units.

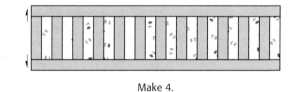

Make 4.

3. Position a 2½" rose square face down on the right side of each of the 48 blue 2½" x 4½" rectangles. Draw a light pencil line diagonally from corner to corner and stitch on line. Cut away the corner ¼" from the stitching. Press the seam toward the rose triangle. Add a rose square to the remaining end of each rectangle in the same manner.

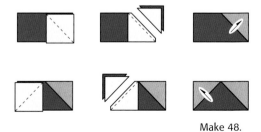

Make 48.

4. Sew the units together, end to end, to make 8 triangle border strips with 6 triangle units in each. Add a triangle border strip to opposite sides of each striped border unit and press toward the green strip. Add a 1½" x 24½" light print strip to the outer edge of each border unit. Press the seams toward the light strips.

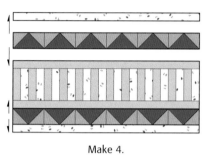

Make 4.

Making the Corner Squares

1. With right sides together, position 2½" rose squares on 2 opposite corners of each of the 4 green-and-rose print 4½" squares. Draw a light pencil line diagonally from corner to corner on the 2½" squares and stitch on the line. Cut away the corners ¼" from the stitching. Press the seams toward the triangles. Add rose squares to the remaining corners of the 4 squares in the same manner. Press.

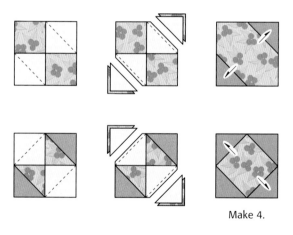

Make 4.

2. For star points, position a 2½" blue square on one end of a 2½" x 4½" green rectangle. As in step 1, draw a line diagonally from corner to corner on the square and stitch diagonally on the line, cut away the corner, and press. Add a blue square to the remaining end of the rectangle in the same manner. Repeat to make a total of 16 star points.

Make 16.

3. Arrange the center squares and star points with 2½" green squares to make 4 Star blocks. Sew the units together in rows and press in the direction of the arrows. Sew the rows together to complete each Star block. Press.

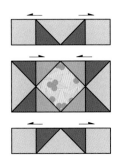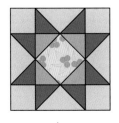

Make 4.

4. Sew a 1½" x 8½" burgundy strip to the top and bottom edges of each Star block. Press the seam toward the burgundy strips. Sew a 1½" x 10½" burgundy strip to the remaining edges of each block. Press. Sew 1½" x 10½" light print strips to the top and bottom. Add 1½" x 12½" strips to the sides. For guidance, refer to the corner squares in the illustration at right.

Assembling the Quilt Top

1. Referring to the diagram, arrange and sew the completed corner squares, striped border units, and 2½" x 12½" large-scale floral strips together in 2 vertical rows. Arrange and sew together the 2½" x 24½" large-scale floral strips, the remaining striped borders, and the center panel to create the center strip. Press the seams toward the floral strips in all panels.

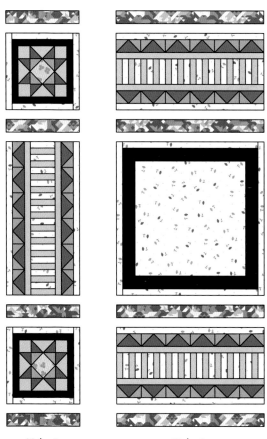

Make 2. Make 1.

2. Cut 2 of the remaining 2½"-wide large-scale print strips in half and sew a half strip to each of the 4 remaining strips. Trim each to 56½". Arrange the strips with the side and center panels in alternating fashion and sew together to complete the quilt top. Press the seams toward the print strips.

Finishing Your Quilt

Refer to the "General Directions," beginning on page 117, for specific directions in each of the following finishing steps.

1. Layer the quilt top with batting and backing; baste.

2. Machine or hand quilt as desired. The center of this quilt is the perfect place to showcase a quilted medallion or flower. For a perfect fit, choose a favorite design template or stencil that is 16" square.

3. Trim the batting and backing even with the quilt-top edges.

4. Sew the 2¾"-wide binding strips together into one long strip and bind the quilt.

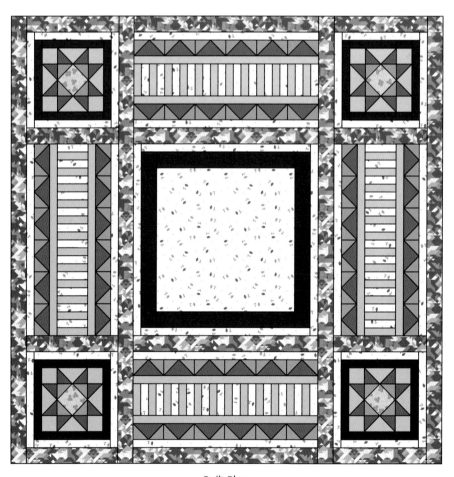

Quilt Plan

Garden Tea

BRING YOUR FAVORITE CHINA teapot and vintage linens to the garden for tea. There's nothing more inviting than mixing these treasures with the natural beauty of a garden. Wild blackberries grow along the road to Larkspur Farm, and they are easily transformed into a delicious pie to serve with tea.

Larkspur Farm Blackberry Pie

1. Use your favorite recipe to make dough for a two-crust pie. Line an 8" pie pan with the bottom crust.
2. For blackberry filling, combine ⅔ cup sugar, ¼ cup flour, and ½ teaspoon cinnamon. Sprinkle the mixture over 3 cups of blackberries and gently stir to coat.
3. Spread the berry filling into the dough-lined pie pan and cover with the top crust. Pinch the crusts together and make a few holes in the top crust to allow the steam to escape.
4. Bake for 30 to 45 minutes at 425° F or until the crust is lightly browned.
5. To serve, top with freshly whipped cream. For a special finishing touch, grate the peel from one lemon and sprinkle over the whipped cream.

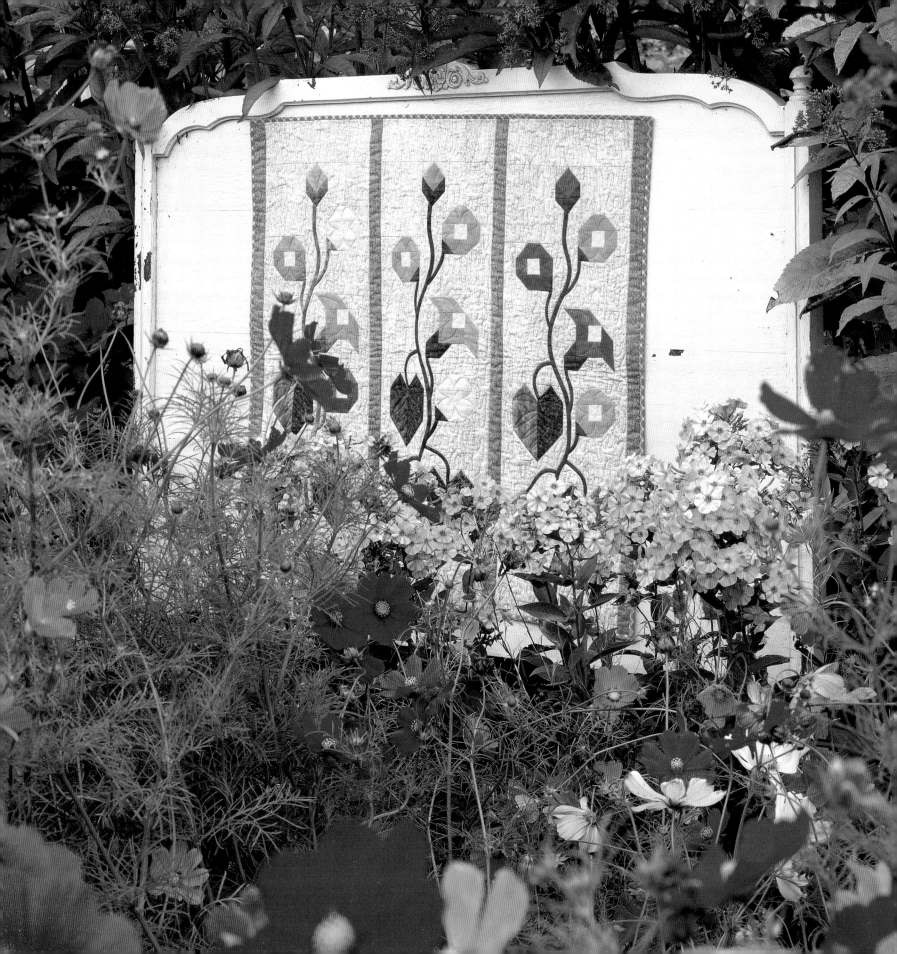

Hollyhocks

As their brilliantly colored flowers reach for the sunshine, stately hollyhocks add a touch of bright color

and a bit of drama to the garden. Vividly shaded versions of this old favorite reach up this wall hanging,

a fitting remembrance of the majestic hollyhocks you'll find in the gardens at Larkspur Farm.

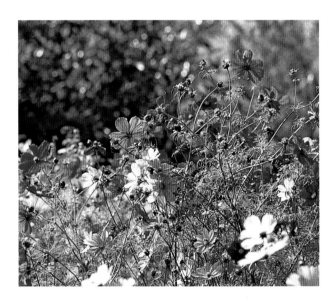
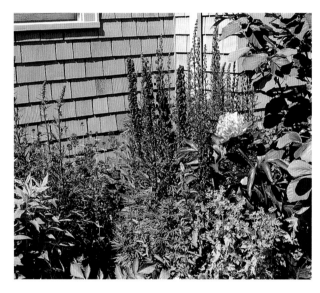

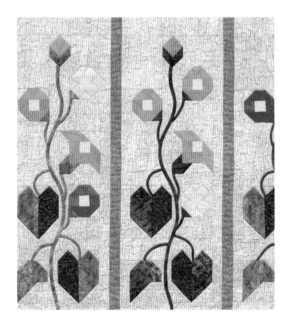

Materials

All yardage is based on 42"-wide fabric unless otherwise stated.

- 1¼ yds. background fabric (non-directional)
- ⅛ yd. light pink for flowers
- ¼ yd. medium pink for flowers
- ⅛ yd. dark pink for flowers
- ⅓ yd. light green for stems and leaves
- 1 fat quarter medium green for stems and leaves
- ⅓ yd. dark green for stems and leaves
- ⅛ yd. yellow for flower centers
- ¼ yd. brown for fence cracks
- 1¼ yds. for backing
- ⅓ yd. for binding
- 38" x 36" piece of batting
- ¼"- and ³⁄₁₆"-wide bias bars (see page 119)

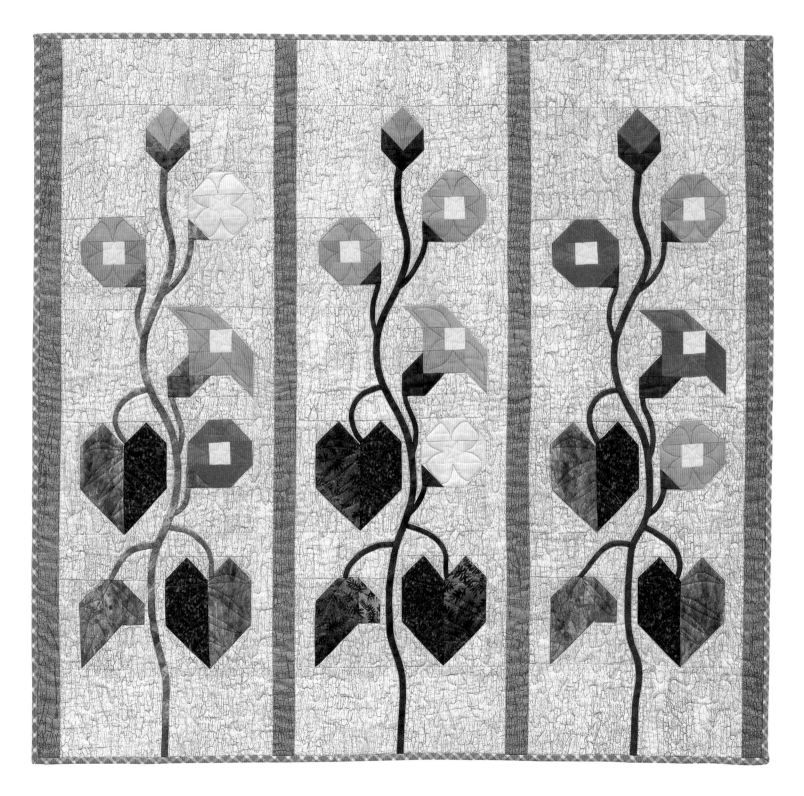

Hollyhocks
By Jean Van Bockel, 2001, Coeur d'Alene, Idaho, 34" x 32".

Cutting

Cut all strips across the fabric width. All measurements include ¼"-wide seam allowances.

From the background fabric, cut:
- 1 strip, 4½" wide; crosscut into 3 strips, each 4½" x 10½"
- 2 strips, each 3½" wide; crosscut into:
 - 3 strips, each 3½" x 10½"
 - 3 rectangles, each 3½" x 4½"
 - 3 squares, each 3½" x 3½"
- 1 strip, 5½" wide; crosscut into:
 - 3 squares, each 5½" x 5½"
 - 3 rectangles, each 4½" x 5½"
- 2 strips, each 2½" wide; crosscut into:
 - 3 rectangles, each 2½" x 6½"
 - 3 rectangles, each 2½" x 5½"
 - 3 rectangles, each 2½" x 4½"
 - 15 squares, each 2½" x 2½"
- 9 strips, each 1½" wide; crosscut into:
 - 3 strips, each 1½" x 10½"
 - 6 strips, each 1½" x 6½"
 - 3 strips, each 1½" x 5½"
 - 15 strips, each 1½" x 4½"
 - 6 rectangles, each 1½" x 3½"
 - 3 rectangles, each 1½" x 2½"
 - 96 squares, each 1½" x 1½"

From the light pink fabric, cut:
- 1 strip, 1½" wide; crosscut into:
 - 4 rectangles, each 1½" x 3½"
 - 4 squares, each 1½" x 1½"

From the medium pink fabric, cut:
- 2 strips, each 1½" wide; crosscut into:
 - 14 rectangles, each 1½" x 3½"
 - 2 rectangles, each 1½" x 2½"
 - 12 squares, each 1½" x 1½"
- 2 squares, each 2½" x 2½"

From the dark pink fabric, cut:
- 1 square, 2½" x 2½"
- 1 strip, 1½" wide; crosscut into:
 - 6 rectangles, each 1½" x 3½"
 - 1 rectangle, 1½" x 2½"
 - 5 squares, each 1½" x 1½"

From the light green fabric, cut:
- 4 bias strips, each 1" x approximately 17" (You will trim to size later.)
- 1 strip, 1½" wide; crosscut into:
 - 3 rectangles, each 1½" x 2½"
 - 10 squares, each 1½" x 1½"
- 1 strip, 2½" wide; crosscut into:
 - 4 rectangles, each 2½" x 5½"
 - 2 rectangles, each 2½" x 4½"

From the medium green fat quarter, cut:
- 3 bias strips, each 1" x approximately 23" (You will trim to size later.)
- 2 rectangles, each 1½" x 2½"
- 10 squares, each 1½" x 1½"
- 2 rectangles, each 2½" x 5½"
- 1 rectangle, 2½" x 4½"

From the dark green fabric, cut:
- 1 strip, 2½" wide; crosscut into:

 6 rectangles, each 2½" x 5½", for the large leaves

 1 rectangle, 1½" x 2½"
- 4 bias strips, each 1" x 17". You will trim to size later.
- 1 strip, 1½" x 18"; crosscut into 10 squares, each 1½" x 1½"

From the yellow fabric, cut:
- 1 strip, 1½" wide; crosscut into 12 squares, each 1½" x 1½"

From the brown fabric, cut:
- 4 strips, each 1½" x 32½", for fence "cracks"

From the binding fabric, cut:
- 4 strips, each 2" wide

Making the Blocks

Pieces for the blocks in this wall hanging are made by placing a square, right side down, on another square or rectangle and stitching diagonally from corner to corner. Use a pencil and ruler to draw lines on the wrong side of the top square in each step, creating a stitching line to follow. Stitch on the pencil line and cut away the corner ¼" from the stitching.

Press the seam toward the triangle. *Pay careful attention to stitching direction and positioning as you stitch squares to rectangles.*

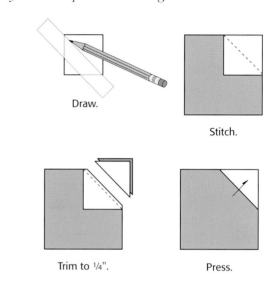

Draw.

Stitch.

Trim to ¼".

Press.

Making the Hollyhock Buds

1. Sew a 1½" background square to each upper corner of a 2½" dark pink square. Add a 1½" medium green square to each remaining corner in the same manner.

2. Sew a 1½" background square to each lower corner of a 1½" x 2½" medium green rectangle. Sew the resulting piece to the bottom edge of the unit from step 1.

Bud

3. Repeat steps 1 and 2 to make 2 more buds. Make 1 with medium pink and dark green pieces and 1 with medium pink and light green pieces.

Making the Open-Face Flowers

1. Sew 1½" background squares on opposite corners of a 1½" x 3½" light pink rectangle. Repeat, using a 1½" background square and a 1½" light green square with a 1½" x 3½" light pink rectangle.

Make 1. Make 1.

2. Sew 1½" light pink squares to opposite edges of a 1½" yellow square. Press the seams toward the pink squares.

3. Join all 3 units from steps 1 and 2 as shown. Press the seams toward the outer units.

Open-face
flower

4. Repeat steps 1–3 to make 8 more flowers in the following color combinations:

 1 light pink and dark green
 1 medium pink and light green
 2 medium pink and dark green
 2 medium pink and medium green
 1 dark pink and light green
 1 dark pink and medium green

Making the Large Flowers

1. Sew 1½" background squares to opposite ends of 2 dark pink 1½" x 3½" rectangles, being careful to position as shown.

Make 1. Make 1.

2. Sew a 1½" background square and a 1½" yellow square to opposite sides of a 1½" dark pink square. Press the seams toward the pink square.

3. With right sides together, place a 1½" background square on each of 2 medium green 1½" squares. Draw a diagonal line from corner to corner on the background square. Stitch on the line and cut ¼" away from the stitching. Discard the cut away triangles and press the seams toward the green triangles. Sew 1 of these units to one end of a 1½" x 2½" dark pink rectangle as shown. Sew a 1½" background square to one end of the remaining unit and a 1½" green square to the other end as shown. Press the seams toward the outer squares.

Make 2.

Make 1. Make 1.

4. Follow the layout below, using the units from steps 1–3 and a 1½" background square, to complete the block. Press seams in the direction of the arrows.

Large flower

5. Repeat to make 2 additional large flower blocks. Use medium pink pieces and light green for one and medium pink and dark green for the other.

Making the Large Leaves

1. Sew 1½" background squares to the upper corners of a 2½" x 5½" light green rectangle. Add a 2½" background square to the lower left corner. Press seams toward the triangles. Repeat, using a dark green 2½" x 5½" rectangle and positioning the 2½" background square in the lower right corner of the rectangle.

Left leaf half Right leaf half

2. Sew the units from step 1 together.

Large leaf

3. Repeat steps 1 and 2 to make 5 additional leaves. Make 3 using light green and dark green pieces, and 2 using medium green and dark green pieces.

Making the Small Leaves

1. Sew a 1½" background square to the upper left end of a 2½" x 4½" medium green rectangle. Add a 2½" background square to the bottom right corner.

2. Sew a 1½" background square to 1 corner of a 1½" x 2½" medium green rectangle. Add a 1½" x 2½" background rectangle to the opposite end of the unit. Press the seam toward the pieced rectangle.

3. Sew the units from steps 1 and 2 together. Repeat to make 2 more small leaves using light green pieces. Press in direction of arrow.

Small leaf

Assembling the Flower Panels

1. Divide the completed flower, leaf, and bud blocks into 3 groups by color: light green, medium green, and dark green.

2. Arrange each group with the required background pieces as shown. Sew pieces together into sections and *press all seams toward the background pieces.* Sew the resulting sections together to complete 3 flower panels.

Adding Stalks and Stems

1. Prepare a ¼" x 30" bias tube in each green shade for the stalks (see "Appliquéd Vines" on page 119). Make a ³⁄₁₆" x 25" bias tube in each green shade for the small stems.

2. Position the stalks on the panels and cut to the required length plus ¾". Refer to the quilt plan on page 116 for placement and baste in place, leaving a ¾" tuck-in allowance at the upper end of each stalk. Add leaf stems in the same manner with a ³⁄₈" tuck-in allowance at each end of the stems.

3. Carefully open the stitching in the seams of the flower blocks where the stalk and stems meet and tuck the raw ends into the opening you've created. Pin in place. Tuck the remaining raw end of each leaf stem under the vine. Pin in place. Stitch the stalks and stems in place using the appliqué stitch (see page 119). Hand sew the opened seams closed.

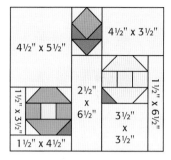

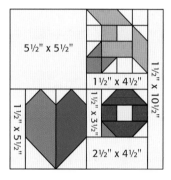

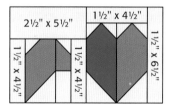

4. Arrange the completed flower panels in alternating fashion with the 1½" x 32½" brown fencing strips and sew together to complete the quilt top.

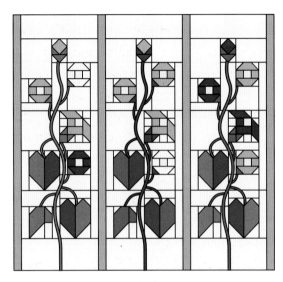

Quilt Plan

Finishing Your Quilt

Refer to the "General Directions," beginning on page 117, for specific directions in each of the following finishing steps.

1. Layer the quilt top with batting and backing; baste.
2. Machine or hand quilt as desired. Vertically oriented stippling in the background adds a woodlike texture to the "fence," which serves as a backdrop for the flowers.
3. Trim batting and backing even with the quilt-top edges.
4. Sew the 2"-wide binding strips together into one long strip and bind the quilt.

General Directions

THIS CHAPTER INCLUDES helpful instructions for completing the projects in this book. Refer to it often if you have questions about quiltmaking techniques. To make sure that you are pleased with your finished quilt, always keep in mind this basic but very important tip:

Stitch accurate ¼"-wide seam allowances and follow the pressing directions with each step before proceeding to the next one.

Appliquéing

Instructions follow for three appliqué methods: freezer-paper, needle-turn, and fusible appliqué.

Freezer-Paper Appliqué

A freezer-paper template stabilizes the appliqué piece during the entire process. You can easily remove the freezer paper by cutting away the backing fabric behind the completed appliqué.

1. Trace the appliqué patterns *in reverse* on the unwaxed (dull) side of the freezer paper. Cut out the templates on the traced lines.

2. Place the freezer-paper template, shiny side down, on the *wrong side* of the chosen fabric and use a dry iron to attach it to the fabric. Leave at least ¾" of space between pieces when attaching more than one freezer-paper template to the same fabric.

3. Cut out each shape, adding a ¼" allowance beyond the template edges. Trim the allowance to ³⁄₁₆" after cutting out each one. Clip inner curves, notch outer curves, and trim points to eliminate bulk.

4. Turn the allowance over the freezer-paper edge and secure with hand basting through the paper and *both* fabric layers.

5. Place the appliqué on the background fabric and sew in place with an appliqué stitch (see "Appliqué Stitch" on page 119). Remove the basting.

6. On the wrong side of the appliqué piece, cut away the background fabric, leaving a ¼" allowance all around. Remove the freezer paper, using your fingers, a needle, or tweezers to gently pull it away from the appliqué.

Background fabric

Freezer paper

¼" seam allowance

Needle-Turn Appliqué

This is the most traditional—and perhaps the most time-consuming—appliqué method. If you love handwork, this is the one for you!

1. Trace the appliqué patterns (as printed) on the unwaxed (dull) side of the freezer paper. Cut out the templates on the traced lines.

2. Place the freezer-paper templates, shiny side down, on the *right* side of the chosen fabric and use a dry iron to attach it to the fabric. Leave at least ¾" of space between pieces when attaching more than one freezer-paper template to the same fabric.

3. Use a No. 2 pencil on light fabric, or a white or yellow pencil on dark fabric to trace around each template.

Trace around
freezer paper template.

4. Cut out the appliqués, adding a scant ¼" allowance all around. Peel away the appliqué template from each piece.

Cut out with ¼" seam allowance
all around.

5. Position the appliqués on the background fabric and pin or baste in place.

6. Starting at a straight area on one edge of each appliqué, use the tip of the needle to turn under the allowance along the marked line about ½" at a time. Clip the seam allowance as needed in curved areas. Sew

in place with the appliqué stitch (see "Appliqué Stitch" on page 119).

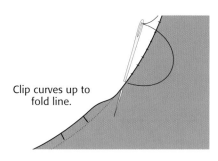

Clip curves up to
fold line.

Fusible Appliqué

This is the quickest appliqué method. Pieces are cut without turn-under allowances and then simply fused to the background. Raw edges may be left exposed or embellished with buttonhole stitching as shown in "Nesting" on page 87. You will need fusible web with a transfer-paper back for this method.

1. Place fusible web, transfer-paper side up, on top of the appliqué pattern and trace the lines. Group all pieces that will be cut from the same pattern with about ¼" of space between them. Cut around the group of appliqué templates.

2. Place the fusible web on the wrong side of the appropriate fabric, paper side up, and fuse, following the manufacturer's directions.

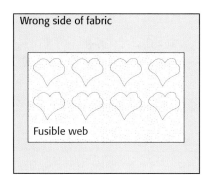

Cut out on traced lines.

3. Cut out the pieces on the traced lines and peel away the paper backing. Position the appliqués, right side up, on the background and fuse in place, following the manufacturer's directions.

Appliqué Stitch

Choose a long, thin needle, such as a Sharp, for stitching.

1. Tie a knot in a single strand of thread that closely matches the appliqué color.

2. Entering the needle from the wrong side of the appliqué, bring the needle up on the fold line, and blindstitch along the folded edge. Take a stitch about every ⅛".

Appliqué stitch

3. To end your stitching, pull the needle through to the wrong side. Take 2 small stitches, making knots by taking your needle through the loops.

4. If desired, trim away the background behind each appliqué, leaving a ¼" allowance all around. This reduces bulk and makes it easier to quilt.

Background fabric

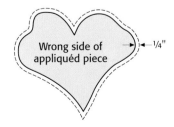

Wrong side of appliquéd piece — ¼"

Appliqué Vines

Use a bias bar to make narrow vines that curve gracefully. Bias bars are flat metal or nylon strips, available in a variety of widths.

1. Cut enough bias strips for your project and join them end to end with diagonal seams (see "Binding" on pages 122–124). Refer to individual project directions for the correct strip width to cut.

2. Fold the bias strip in half lengthwise with wrong sides together. Measure from the fold the width of the bias bar plus ⅛". Stitch this distance from the fold for the length of the bias strip, taking care not to stretch the bias as you go.

3. Trim the seam allowance to ⅛". Slip the bias bar (in the width of your choice) into the fabric tube and adjust so the seam is centered on the bar. Steam press to flatten the tube, pressing the seam allowance to one side.

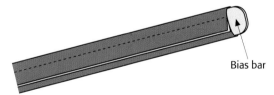

Bias bar

4. Remove the bias bar. Position the strip as desired on the background fabric and appliqué in place.

Adding Borders

Following are the most basic directions for borders. Slight variations of this method may appear throughout this book due to the nature of the border design.

Straight-Cut Borders

1. Measure the length of the quilt top through the center. Cut border strips to this measurement, piecing as necessary. Mark the center of the quilt edges and the border strips. Pin the border strips to the sides of the quilt top, matching the center marks and ends and easing as necessary. Sew the border strips in place. Press the seams toward the border.

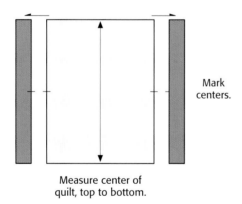

Mark centers.

Measure center of quilt, top to bottom.

2. Measure the width of the quilt top through the center, including the side border strips just added. Cut border strips to this measurement, piecing as necessary. Mark the center of the quilt edges and the border strips. Pin the border strips to the top and bottom edges of the quilt top, matching the center marks and ends and easing as

necessary; stitch. Press the seams toward the border.

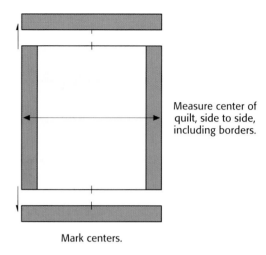

Measure center of quilt, side to side, including borders.

Mark centers.

Mitered Borders

Strips for mitered borders are cut extra long and trimmed to fit after stitching the mitered corners.

1. To add a border with mitered corners, measure the quilt top through the center and mark this length on the border with a pin at each end. Pin-mark the center of the strip. Pin the border strip to the edge, matching the border center to the quilt-top center, with the pins at the ends. An even amount of the excess border strip should extend beyond each end of the quilt top.

2. Stitch, beginning and ending the seam ¼" from the quilt-top corners. Repeat with the remaining border strips.

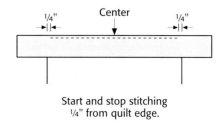

¼" Center ¼"

Start and stop stitching ¼" from quilt edge.

3. Working on a flat surface, place one border on top of the other at a 90° angle.

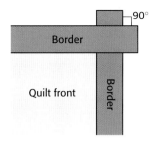

4. Turn the top border layer back at a 45° angle and press to mark the stitching line.

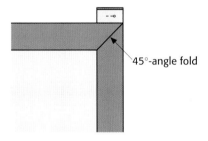

45°-angle fold

5. With right sides together, pin the borders together and sew on the pressed crease, backstitching as you begin and end the stitching.

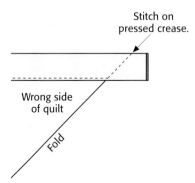

Stitch on pressed crease.

Wrong side of quilt

Fold

6. Trim away the excess border fabric, leaving a ¼"-wide seam allowance. Press the seam open. Repeat with the remaining corners.

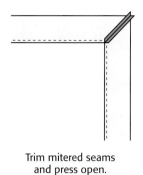

Trim mitered seams and press open.

Layering the Quilt

The quilt "sandwich" consists of the backing, batting, and quilt top. We recommend cutting the quilt backing *at least* 4" larger than the quilt top all around.

For large quilts, it is usually necessary to sew two or three lengths of fabric together to make a backing of the required size. Trim away the selvage edges (they are more difficult to quilt through) before sewing the lengths together. Press the backing seams open to make quilting easier.

OR

1. Spread the backing, wrong side up, on a flat, clean surface. Anchor it with pins or masking tape. Be careful not to stretch the backing out of shape.
2. Spread the batting over the backing, smoothing out any wrinkles.
3. Place the pressed quilt top, right side up, on top of the batting. Smooth out any wrinkles and make sure the edges of the quilt top are parallel to the edges of the backing.
4. For hand quilting, start in the center and hand baste the layers together in a grid of horizontal and vertical lines spaced 6" to 8" apart. Baste around the outer edges of the quilt top.

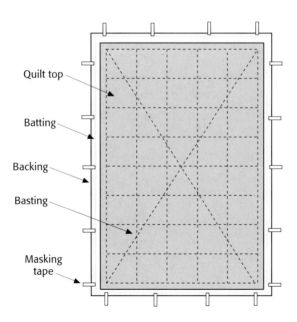

Quilt top

Batting

Backing

Basting

Masking tape

For machine quilting, pin the layers together using #1, nickel-plated safety pins. Begin pinning in the center, working toward the outside edges and placing pins every 3" to 4" throughout.

Quilting

Choose your favorite quilting method to quilt your project. All of the projects in *Quilts from Larkspur Farm* were machine quilted. We have included some excellent books on machine and hand quilting in the resource list on page 125. Following are a few machine quilting tips.

- Machine quilting is suitable for all quilt types, from crib- to full-size bed quilts. With machine quilting, you can quickly complete quilts that might otherwise languish on your shelves.
- For straight-line quilting, it is extremely helpful to have a walking foot to feed the quilt layers through the machine without shifting or puckering. Some machines have a built-in walking foot or even-feed feature; other machines require a separate attachment.
- Use free-motion quilting to outline a quilt pattern in the fabric or to create stippling and many other curved designs. You will need a darning foot and the ability to drop the feed dogs on your machine. Instead of turning the fabric to change directions, you guide the fabric in the direction of the design, using the needle like a "pencil."

Binding
Straight-Cut Binding

To make straight-cut, double-layer (French) binding, cut strips 2" to 2¾" wide, depending on the desired finished width (¼" to ⅜") of the binding. Cut strips across the fabric width. You will need enough strips to go around the perimeter of the quilt, plus 10" for seams and the corners in the mitered folds.

1. With right sides together, sew the strips together on the diagonal as shown to create one long strip. Trim excess fabric and press the seams open.

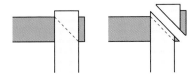

2. Fold the strip in half lengthwise, wrong sides together, and press. Turn under ¼" at a 45° angle at one end of the strip and press.

Fold line

3. Trim the batting and backing even with the quilt-top edges, making sure the corners are square.

4. Beginning on one edge of the quilt and using a ¼"-wide seam allowance, stitch the binding to the quilt, keeping the raw edges even with the quilt-top edge. End the stitching ¼" from the corner of the quilt and backstitch.

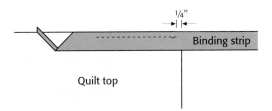

¼"

Binding strip

Quilt top

5. Fold the binding up, away from the quilt, then back down onto itself, aligning the raw edges with the quilt-top edge. Begin stitching at the edge, backstitching to

secure, and end ¼" from the lower edge. Repeat on the remaining edges.

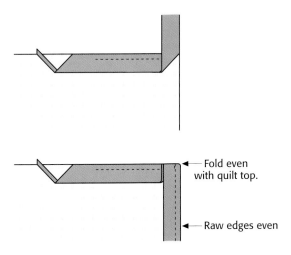

Fold even with quilt top.

Raw edges even

6. When you reach the beginning of the binding, lap the strip over the beginning stitches by about 1" and cut away any excess binding, trimming the end at a 45° angle. Tuck the end of the binding into the fold and complete the seam.

7. Fold the binding over the raw edges of the quilt to the back, with the folded edge just covering the machine stitching. Blindstitch in place, including the miter that forms at each corner.

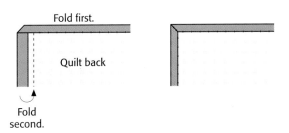

Fold first.

Quilt back

Fold second.

Bias Binding

Plaid and stripe fabrics look especially drama- tic when cut on the bias and used for binding or appliquéd vines. Bias-cut binding is also necessary when your quilt has curved outer edges as in "Nesting" on page 87.

Place a ruler with a 45°-angle marking on a single layer of fabric that has been placed on your rotary-cutting mat. Cut as many bias strips as needed for the quilt you are making. Or, cut 1"-wide strips for appliquéd vines.

45° line on ruler

If you are using bias strips for your quilt binding, follow steps 1–3 in "Straight-Cut Binding" on pages 122–123 to assemble the binding strip and prepare the quilt for bind- ing. For quilts with square corners, follow the remaining steps 4–7 to apply the binding. If your quilt has rounded corners, begin the binding application as directed in step 4. Pin the binding around the first curve, taking care not to stretch the binding. (If you stretch the binding, the corners will curl.) Continue in this manner around the entire quilt and finish the binding as directed in steps 6 and 7.

If you are making stems and vines, refer to "Appliqué Vines" on page 119.

Resource Books

Here are some of our favorite resources for quiltmaking. We recommend them for learning more about various techniques that we have used for the quilts in this book.

Doak, Carol. *Your First Quilt Book (or it should be!)*. Bothell, Wash.: That Patchwork Place, 1996.

Eddy, Ellen Anne. *Thread Magic*. Bothell, Wash.: That Patchwork Place, 1997.

Mazuran, Cody. *A Fine Finish: New Bindings for Award-Winning Quilts*. Bothell, Wash.: That Patchwork Place, 1996.

Noble, Maurine. *Machine Quilting Made Easy*. Bothell, Wash.: That Patchwork Place, 1994.

Thomas, Donna Lynn. *Shortcuts: A Concise Guide to Rotary Cutting*. Bothell, Wash.: Martingale & Company, 1999.

Townswick, Jane. *Artful Appliqué the Easy Way*. Bothell, Wash.: Martingale & Company, 2000.

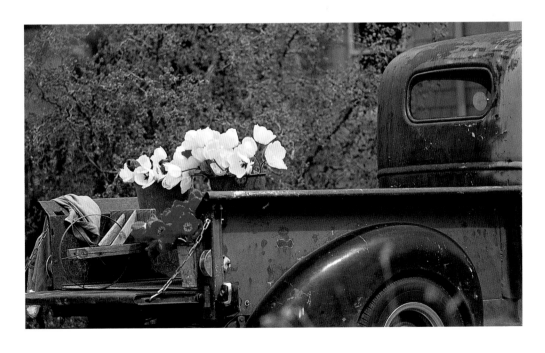

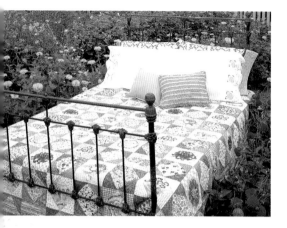

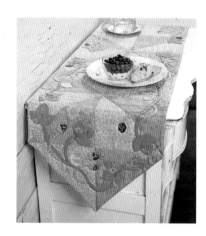

Jean Van Bockel and Pamela Mostek

About the Authors

Jean Van Bockel is never too far from her favorite kind of project: appliqué. She always has a project under way to work on when she has a few extra minutes. Jean's love of stitching is long-standing. Since she joined 4-H when she was about twelve years old, she has made just about everything that's possible with a needle and thread!

Quilting became a passion later—about fifteen years ago when she joined a quilt group in Snohomish, Washington. She feels so fortunate to have learned from many accomplished quilters over the years and attributes much of her skill and knowledge to her current quilt group, The Out to Lunch Bunch, whom she calls an exceptionally talented group of quilters.

Jean and her husband, Mark, live in Coeur d'Alene, Idaho, and are the parents of three grown children.

Pamela Mostek has loved making pretty things for as long as she can remember. As a child, she and her mother were always involved in making some exciting project. With this early history, it was a natural choice for her to pursue a degree in art and education, followed by fifteen years as a high school art teacher, spreading her love of creating.

With her background in the arts, Pam has enjoyed working in a variety of areas, such as watercolor and decorative painting, weaving, and fabric surface design. Some fifteen years ago, she arrived at quilting, where it all came together, and it has been her passion ever since. Today, she spends her time designing and creating quilts for books and her pattern company, Making Lemonade Designs.

Pam and her husband, Bob, live in Cheney, Washington. They have two grown daughters, who share Pam's love of quilting, and three beautiful grandchildren.

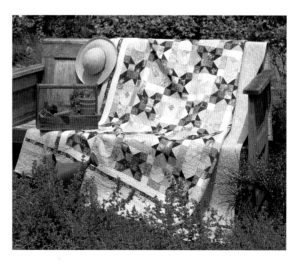

new and bestselling titles from

America's Best-Loved Craft & Hobby Books®

America's Best-Loved Quilt Books®

NEW RELEASES
1000 Great Quilt Blocks
Basically Brilliant Knits
Bright Quilts from Down Under
Christmas Delights
Creative Machine Stitching
Crochet for Tots
Crocheted Aran Sweaters
Cutting Corners
Everyday Embellishments
Folk Art Friends
Garden Party
Hocus Pocus!
Just Can't Cut It!
Quilter's Home: Winter, The
Sweet and Simple Baby Quilts
Time to Quilt
Today's Crochet
Traditional Quilts to Paper Piece

APPLIQUÉ
Appliquilt in the Cabin
Artful Album Quilts
Artful Appliqué
Blossoms in Winter
Color-Blend Appliqué
Sunbonnet Sue All through the Year

BABY QUILTS
Easy Paper-Pieced Baby Quilts
Even More Quilts for Baby
More Quilts for Baby
Play Quilts
Quilted Nursery, The
Quilts for Baby

HOLIDAY QUILTS & CRAFTS
Christmas Cats and Dogs
Creepy Crafty Halloween
Handcrafted Christmas, A
Make Room for Christmas Quilts
Welcome to the North Pole

HOME DECORATING
Decorated Kitchen, The
Decorated Porch, The
Dresden Fan
Gracing the Table
Make Room for Quilts
Quilts for Mantels and More
Sweet Dreams

LEARNING TO QUILT
101 Fabulous Rotary-Cut Quilts
Beyond the Blocks
Casual Quilter, The
Feathers That Fly
Joy of Quilting, The
Simple Joys of Quilting, The
Your First Quilt Book (or it should be!)

PAPER PIECING
40 Bright and Bold Paper-Pieced Blocks
50 Fabulous Paper-Pieced Stars
For the Birds
Quilter's Ark, A
Rich Traditions
Split-Diamond Dazzlers

ROTARY CUTTING
365 Quilt Blocks a Year Perpetual
 Calendar
Around the Block Again
Around the Block with Judy Hopkins
Fat Quarter Quilts
More Fat Quarter Quilts
Stack the Deck!
Triangle Tricks
Triangle-Free Quilts

SCRAP QUILTS
Nickel Quilts
Scrap Frenzy
Scrappy Duos
Spectacular Scraps
Strips and Strings
Successful Scrap Quilts

TOPICS IN QUILTMAKING
American Stenciled Quilts
Americana Quilts
Batik Beauties
Bed and Breakfast Quilts
Fabulous Quilts from Favorite Patterns
Frayed-Edge Fun
Patriotic Little Quilts
Reversible Quilts

CRAFTS
ABCs of Making Teddy Bears, The
Blissful Bath, The
Handcrafted Frames
Handcrafted Garden Accents
Handprint Quilts
Painted Chairs
Painted Whimsies

KNITTING & CROCHET
365 Knitting Stitches a Year Perpetual
 Calendar
Clever Knits
Crochet for Babies and Toddlers
Crocheted Sweaters
Knitted Sweaters for Every Season
Knitted Throws and More
Knitter's Book of Finishing Techniques,
 The
Knitter's Template, A
More Paintbox Knits
Paintbox Knits
Too Cute! Cotton Knits for Toddlers
Treasury of Rowan Knits, A
Ultimate Knitter's Guide, The

Our books are available at bookstores and your favorite craft, fabric and yarn retailers. If you don't see the title you're looking for, visit us at www.martingale-pub.com or contact us at:

1-800-426-3126 • International: 1-425-483-3313

Fax: 1-425-486-7596 • E-mail: info@martingale-pub.com

For more information and a full list of our titles, visit our Web site.